TATTOO FOR BEGINNERS TO INTERMEDIATE

A 30-Day Journey to Body Art Mastery – A Step-by-Step Guide to Enhancing Your Skills, Techniques, Styles, and Creative Growth

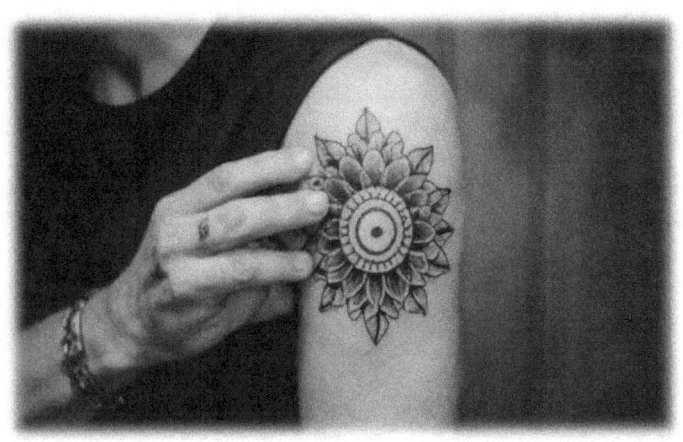

Roy E. Gutierrez

Disclaimer / Copyright © 2024. All Rights Reserved.

No part of this book may be reproduced, distributed, or transmitted in any form or by any means, including photocopying, recording, or other electronic or mechanical methods, without the prior written permission of the author. Exceptions are made for brief quotations in critical reviews and certain other non-commercial uses permitted by copyright law.

TABLE OF COTENT

Chapter 1 ..12
History of Tattooing: Exploring the Origins and Cultural Significance of Tattoos Across Different Societies12

- Modern Tattoo Culture: Understanding the Current Trends and the Evolution of Tattooing in Contemporary Times...................................17
- Overview of Tattooing as an Art Form: Discussing Tattooing as a Medium of Personal Expression and Its Artistic Value20
- Setting Goals for the 30-Day Journey: What to Expect and How to Maximize the Benefits from This Guide...22
 - Setting Achievable Goals ..23
 - Maximizing the Benefits of the Program ..25

Chapter 2 ..26
Getting Started – Essential Tools and Equipment..........26

- Tattoo Machines and Needles: Types, Uses, and Maintenance32
- Inks and Their Properties: Different Types of Inks and Their Applications ..36
- Workspace Setup: Creating a Clean, Organized, and Efficient Workspace ..40
- Safety and Hygiene Practices: Importance of Sterilization and Infection Prevention ...44

Chapter 3 ..48
Skin and Anatomy ...48

- Understanding Skin Layers: How Tattoos Interact with the Skin........54
- Placement Considerations: Best Practices for Different Body Parts...55

Healing Process: Stages of Healing and How to Advise Clients on Aftercare ... 57

Advising Clients on Aftercare ... 59

Chapter 4 ... 61

Designing Tattoos ... 61

Fundamentals of Tattoo Design: Basic Principles of Creating Visually Appealing Designs .. 68

Drawing and Sketching Techniques: Improving Your Freehand Skills 71

Digital Design Tools: Utilizing Software for Tattoo Design 74

Creating Custom Designs: Working with Clients to Develop Unique, Personalized Tattoos .. 77

Chapter 5 ... 81

Tattoo Styles and Techniques ... 81

Traditional vs. Modern Styles: Exploring Various Tattoo Styles 86

Line Work and Shading Techniques: Mastering the Basics of Lines and Shading .. 89

Color Theory and Application: Understanding How Colors Work Together and How to Apply Them Effectively 92

Chapter 6 ... 97

Practicing on Synthetic Skin and Live Models 97

Transitioning to Live Models: Tips for Making the Switch 106

Conducting a Practice Session: How to Organize and Execute a Practice Tattoo Session ... 109

Chapter 7 ... 113

The Tattooing Process ... 113

Preparing the Client and Work Area: Steps to Ensure a Smooth Tattooing Session .. 120

Outlining and Shading: Detailed Techniques for Both Outlining and Shading ..123

Coloring and Finishing Touches: How to Apply Color and Final Touches for a Professional Finish ..127

Chapter 8 ..133

Advanced Techniques and Specializations133

Portraits and Realism: Techniques for Creating Lifelike Tattoos141

Cover-ups and Corrections: How to Handle and Fix Old or Unwanted Tattoos ..143

Special Effects and 3D Tattoos: Adding Depth and Dimension to Your Work ..146

Chapter 9 ..149

Building Your Portfolio and Brand149

Marketing Yourself as an Artist: Utilizing Social Media and Other Platforms ..158

Chapter 10 ..161

The Business of Tattooing ...161

Setting Up Your Tattoo Business: Legal Considerations, Licensing, and Business Models ..168

Pricing Your Work: How to Determine Fair Pricing for Your Tattoos 172

Ethics and Professionalism: Maintaining High Standards in Your Practice ..178

Conclusion ...181

INTRODUCTION

"The human body is the best work of art." - Jess C. Scott

The Rich History of Tattooing

Tattooing, a practice that has existed for thousands of years, is more than just a method of body decoration. It is a profound form of self-expression and cultural identity. The earliest evidence of tattooing dates back to around 5,200 years ago with the discovery of Ötzi the Iceman, whose body was adorned with 61 tattoos. These markings, which are believed to have been therapeutic, reflect the long-standing relationship between tattoos and human civilization.

Tattooing has traversed through various cultures and epochs, each adding its unique touch. In ancient Egypt, tattoos were found on female mummies, often symbolizing fertility and protection. In Polynesia, the art of tattooing was deeply spiritual, with each tattoo telling a story about the individual's lineage, achievements, and social status. The Maori of New Zealand practiced Tā Moko, a form of tattooing that involved intricate facial designs signifying the wearer's genealogy and personal history.

In Japan, Irezumi, the traditional Japanese tattooing method, has evolved over centuries into an elaborate art form featuring detailed and vibrant designs. In Western cultures, tattooing has seen varied acceptance, from being a symbol of rebellion to a mainstream form of artistic expression.

Modern Tattoo Culture

The modern era of tattooing began to take shape in the 19th and 20th centuries, largely influenced by Western sailors who encountered indigenous tattooing practices during their voyages. These early adopters brought tattooing back to Europe and North America, where it slowly began to gain popularity.

Samuel O'Reilly's invention of the electric tattoo machine in 1891 revolutionized the practice, making it more accessible and allowing for greater precision and detail. This technological advancement laid the groundwork for the explosion of tattoo culture that we see today.

In contemporary society, tattoos are a ubiquitous element of popular culture. They have transcended social classes and stereotypes, becoming a widely accepted and respected form of art. Tattoos now adorn the bodies of celebrities, professionals, and everyday people, each design a unique representation of individual identity, beliefs, and experiences.

Tattooing as an Art Form

Tattooing is a dynamic and multifaceted art form that requires a deep understanding of various artistic principles. Unlike traditional art forms, tattooing presents unique challenges due to the canvas—the human skin. Skin varies in texture, elasticity, and tone, requiring the artist to adapt their techniques accordingly.

Tattoo artists must master a range of skills, from drawing and shading to understanding color theory and anatomy. The ability to translate a two-dimensional design onto the three-dimensional, living canvas of the human body is what sets tattoo artists apart from other artists. This skill requires precision, creativity, and an intimate knowledge of how the skin will react to the tattooing process.

Moreover, tattooing is not just about creating visually appealing designs. Each tattoo carries personal significance for the wearer, often symbolizing important life events, beliefs, or aspects of their identity. This adds an emotional and psychological dimension to the art of tattooing, making it a deeply personal and impactful experience.

Setting Goals for the 30-Day Journey

Embarking on this 30-day journey to tattoo mastery is an exciting and rewarding endeavor. This guide is designed to take you from the basics of tattooing to more advanced techniques, ensuring that you build a solid foundation and develop your skills progressively.

To make the most of this journey, it's essential to set clear and achievable goals. Here are some key objectives to focus on:

- Master the Basics: Understand the fundamental principles of tattooing, including tool selection, workspace setup, and basic techniques.
- Develop Artistic Skills: Improve your drawing and design skills, focusing on creating custom designs that reflect your unique style and vision.
- Gain Technical Proficiency: Learn and practice the technical aspects of tattooing, such as outlining, shading, and coloring.
- Build a Portfolio: Start creating a professional portfolio that showcases your best work and demonstrates your growth as an artist.
- Understand Safety and Hygiene: Emphasize the importance of safety and hygiene practices to ensure a safe and professional tattooing environment.
- Explore Tattoo Styles: Familiarize yourself with different tattoo styles and techniques, and experiment with incorporating these into your work.
- Engage with the Community: Connect with other tattoo artists and enthusiasts, participate in workshops and conventions, and stay updated with the latest trends and innovations in the tattoo industry.

Chapter 1

History of Tattooing: Exploring the Origins and Cultural Significance of Tattoos Across Different Societies

"Show me a man with a tattoo and I'll show you a man with an interesting past." - Jack London

The Beginnings of Tattooing

Tattooing is an ancient practice, with its roots stretching back to the dawn of human civilization. Archaeological evidence suggests that tattooing dates back over 5,000 years, as seen in the discovery of Ötzi the Iceman, whose well-preserved body was found in the Alps. Ötzi's skin bore a series of tattoos, primarily composed of simple lines and dots, believed to have been part of a therapeutic treatment. These early markings highlight how deeply ingrained the practice of tattooing was in human culture, even in prehistoric times.

Ancient Egypt and the Mediterranean

In ancient Egypt, tattoos were predominantly found on female mummies, indicating their use in rites and rituals related to fertility and protection. The most notable of these is the priestess Amunet, whose body displayed intricate patterns that likely signified her status and role within society. Tattoos in ancient Egypt were also used to mark slaves and prisoners, serving as a form of identification and control.

Further west, in ancient Greece and Rome, tattooing had a different connotation. Greeks and Romans used tattoos primarily for punitive purposes, marking criminals and slaves. The Greek term "stigma" originally referred to the tattoo marks given to these individuals. Despite this, tattoos also held a place in military culture. Roman soldiers often bore tattoos that indicated their unit and rank, serving both as a form of identification and as a symbol of their commitment.

The Polynesian Influence

Tattooing reached its artistic zenith in Polynesia, where it was more than just an art form; it was a rite of passage, a spiritual journey, and a statement of identity. The word "tattoo" itself is derived from the Polynesian word "tatau," meaning to mark or strike. Polynesian tattooing was a highly ritualized process, often accompanied by significant ceremonies. Each design was unique, telling a story about the wearer's lineage, achievements, and social status.

In Polynesian culture, the act of tattooing was performed by highly respected artists known as "tufuga." These experts used tools made from bone and wood to create their intricate designs, which covered large portions of the body. The designs themselves were rich with symbolism, often representing the wearer's ancestors, protective spirits, and personal attributes. The practice of tattooing was so integral to Polynesian society that individuals without tattoos were often seen as incomplete.

The Maori of New Zealand

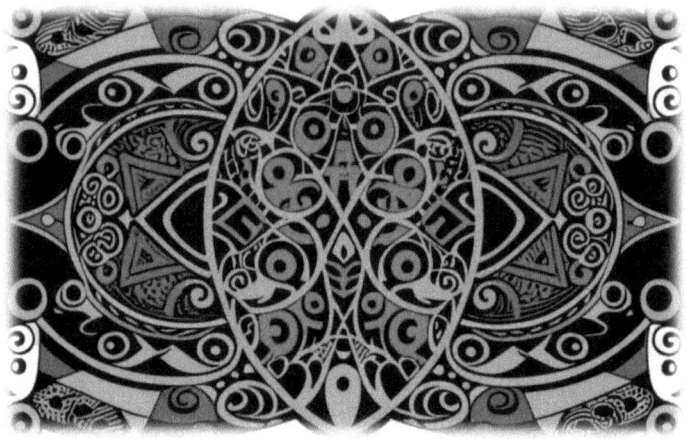

The Maori of New Zealand practiced a distinct form of tattooing known as "Tā Moko," which involved carving the skin with chisels rather than puncturing it with needles. This method created grooves in the skin, resulting in a textured, raised tattoo. Tā Moko designs were deeply personal, often depicting the wearer's genealogy, social status, and achievements. Each line and curve in a Maori tattoo held specific meanings, making the tattoos a form of living history.

The process of receiving a Tā Moko was a significant cultural event, accompanied by various rituals and ceremonies. It was believed that the tattooing process not only adorned the body but also enriched the spirit, connecting the individual to their ancestors and cultural heritage. The face was the most sacred area for Maori tattoos, with each section representing different aspects of the person's identity, such as their family, tribe, and achievements.

Japanese Irezumi

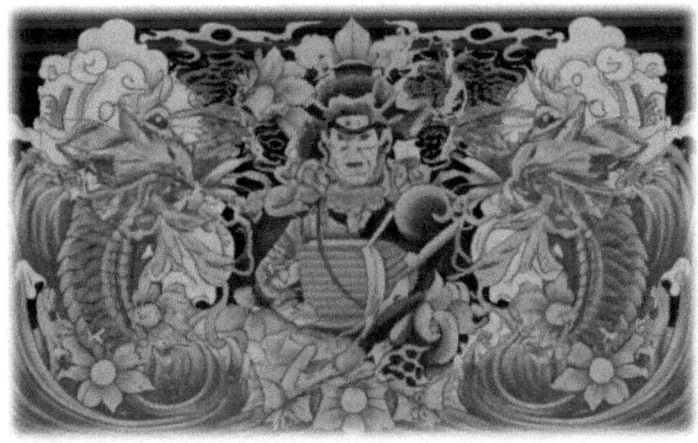

In Japan, the art of tattooing, known as "Irezumi," has a complex history, evolving from a form of punishment to a celebrated art form. During the Edo period (1603-1868), tattoos were used to mark criminals, with each crime associated with specific markings. However, by the late Edo period, tattooing began to flourish as an underground art form, particularly among the working class and members of the Yakuza.

Japanese tattoos are renowned for their intricate designs and vibrant colors, often depicting mythological creatures, historical figures, and elements of nature. The practice of Irezumi involves hand-poking the skin with needles attached to wooden handles, a technique that requires immense skill and patience. The full-body suits, which cover large areas of the body, are masterpieces of artistry, blending traditional themes with modern aesthetics.

Indigenous Tribes of the Americas

Tattooing also held significant cultural importance among various indigenous tribes in the Americas. In North America, tribes such as the Haida, Inuit, and Cree used tattoos for spiritual and social purposes. Tattoos often represented totemic animals, clan affiliations, and personal achievements. For example, Inuit women would receive chin tattoos to signify their readiness for marriage and their role within the community.

In Central and South America, the Maya, Aztec, and Inca civilizations also practiced tattooing. The designs were often elaborate and held deep religious and cultural significance. Warriors would receive tattoos as marks of bravery and prowess in battle, while priests and shamans adorned themselves with tattoos that represented their spiritual journeys and connections to the divine.

Tattooing in Southeast Asia

In Southeast Asia, tattooing is an ancient and revered tradition. The Kalinga people of the Philippines, for example, have practiced tattooing for over a thousand years. The designs, known as "batok," are created using a thorn from a citrus tree and a wooden hammer. These tattoos often symbolize strength, bravery, and protection. Among the Kalinga, tattoos were also a mark of beauty and status, with intricate designs adorning both men and women.

In Thailand, the practice of "Sak Yant" tattooing combines intricate designs with religious and spiritual elements. Sak Yant tattoos are believed to bestow protection, strength, and good fortune upon the wearer. These tattoos are traditionally given by Buddhist monks or Brahmin priests, who imbue the designs with prayers and blessings. The intricate patterns often include sacred geometry, depictions of animals, and powerful symbols.

The Western Evolution

Tattooing in Western cultures has seen a dramatic evolution, moving from the fringes of society to mainstream acceptance. In the 18th century, European sailors encountered tattooing during their voyages to the South Pacific and brought the practice back to Europe. These early tattoos were often simple designs, such as anchors, ships, and mermaids, symbolizing the sailors' travels and experiences.

By the late 19th century, tattooing had gained popularity among the European aristocracy and American elite. Samuel

O'Reilly's invention of the electric tattoo machine in 1891 revolutionized the practice, making it more accessible and allowing for greater detail and precision in designs. This technological advancement paved the way for the flourishing tattoo culture of the 20th and 21st centuries.

Today, tattoos are a widely accepted and respected form of self-expression and artistry. The stigma that once surrounded tattooing has largely faded, with people from all walks of life embracing the art form. Modern tattoo artists push the boundaries of creativity, blending traditional techniques with contemporary styles to create truly unique and personal works of art.

Modern Tattoo Culture: Understanding the Current Trends and the Evolution of Tattooing in Contemporary Times

Tattoo culture today is a vibrant tapestry of artistic expression, personal identity, and cultural exchange. It reflects the diversity and complexity of modern society, with each tattoo carrying a unique story. The journey from the marginalized practice of earlier centuries to the mainstream art form it is today has been marked by significant changes in societal attitudes, technological advancements, and evolving artistic trends.

In recent decades, tattoos have become a symbol of personal expression and individuality. Unlike the past, when tattoos were often associated with rebellion and nonconformity, today they are embraced by people from all walks of life. Celebrities, athletes, professionals, and everyday individuals proudly

display their body art, contributing to the normalization and acceptance of tattoos. This widespread acceptance is partly due to the growing visibility of tattoos in media and popular culture, where they are frequently showcased in movies, television shows, and social media platforms.

Technological advancements have played a crucial role in shaping modern tattoo culture. The development of sophisticated tattoo machines and high-quality inks has revolutionized the practice, allowing artists to achieve greater precision and detail in their work. These innovations have expanded the possibilities for tattoo designs, enabling intricate patterns, realistic portraits, and vibrant colors that were previously unattainable. Additionally, advancements in aftercare products have improved the healing process, ensuring that tattoos remain vibrant and well-preserved over time.

The rise of social media has also had a profound impact on the tattoo industry. Platforms like Instagram and TikTok have become essential tools for tattoo artists to showcase their work, connect with clients, and gain a global following. This digital exposure has democratized the industry, allowing talented artists to gain recognition regardless of their geographical location. Social media has also facilitated the exchange of ideas and techniques, fostering a sense of community and collaboration among artists worldwide.

Modern tattoo trends are diverse and constantly evolving, reflecting the dynamic nature of contemporary culture. Minimalist tattoos, characterized by simple lines and geometric shapes, have gained popularity for their subtlety and elegance. Watercolor tattoos, which mimic the appearance of watercolor paintings, offer a softer and more fluid aesthetic. Hyperrealism,

a style that aims to create lifelike representations, has pushed the boundaries of what is possible in tattoo artistry. Other trends, such as blackwork, dotwork, and neo-traditional styles, continue to captivate enthusiasts with their unique characteristics and artistic depth.

The growing acceptance of tattoos has also led to the emergence of specialized tattoo genres. Medical tattoos, for instance, serve practical purposes such as covering scars, reconstructing nipples after mastectomies, or indicating medical conditions. Cosmetic tattoos, including microblading and permanent makeup, enhance facial features and provide long-lasting beauty solutions. Cultural tattoos, which draw inspiration from traditional practices and symbols, allow individuals to connect with their heritage and honor their roots.

Despite the widespread acceptance, the tattoo industry still faces challenges. Issues such as tattoo regulation, health and safety standards, and the need for professional training remain important considerations. However, the increasing professionalism within the industry and the establishment of reputable tattoo conventions and organizations are addressing these concerns and promoting ethical practices.

In conclusion, modern tattoo culture is a rich and multifaceted phenomenon that continues to evolve and inspire. It reflects the diversity of human experiences and the enduring desire for self-expression. As tattooing becomes more mainstream, it will undoubtedly continue to push artistic boundaries, embrace new technologies, and celebrate the unique stories that each tattoo carries.

Overview of Tattooing as an Art Form: Discussing Tattooing as a Medium of Personal Expression and Its Artistic Value

Tattooing is a unique and powerful art form that transcends traditional boundaries of artistic expression. Unlike other art forms that exist in galleries or on canvases, tattoos are living artworks, permanently etched into the skin. This inherent intimacy and permanence give tattoos a profound depth, transforming the human body into a canvas that tells personal stories and expresses individual identities.

At its core, tattooing is a deeply personal form of self-expression. Each tattoo holds significance for the wearer, whether it commemorates a milestone, honors a loved one, symbolizes a belief, or simply reflects an aesthetic preference. The decision to get a tattoo is often a deliberate and meaningful one, making the resulting artwork a reflection of the wearer's journey, values, and experiences. This personal connection imbues tattoos with an emotional and psychological resonance that is unparalleled in other art forms.

Tattoo artists are skilled practitioners who combine technical proficiency with creative vision. The process of creating a tattoo involves a blend of artistry and precision, as artists must understand not only the principles of design but also the unique properties of human skin. Skin is a dynamic and varied canvas, requiring artists to adapt their techniques to different textures, tones, and contours. This adaptability and skill are what set tattoo artists apart and elevate tattooing to a respected art form.

The artistry involved in tattooing encompasses various styles and techniques, each with its own aesthetic and cultural significance. Traditional tattoos, with their bold lines and limited color palettes, draw from the rich history of tattooing practices around the world. Realism tattoos aim to create lifelike representations, showcasing the artist's ability to capture fine details and subtle nuances. Abstract and surreal tattoos push the boundaries of imagination, transforming skin into a realm of fantasy and symbolism. Each style requires mastery of specific skills, from shading and line work to color theory and composition.

Tattooing also involves a collaborative process between the artist and the client. Unlike other art forms where the artist works independently, tattooing requires an intimate dialogue to ensure the final design aligns with the client's vision and desires. This collaboration fosters a deep connection between the artist and the client, resulting in a piece of art that is both aesthetically pleasing and personally meaningful. The trust and communication involved in this process are essential, as they influence the success and satisfaction of the final tattoo.

The artistic value of tattooing is further highlighted by its cultural significance. Throughout history, tattoos have been used to convey social status, spiritual beliefs, and cultural heritage. They have served as rites of passage, symbols of allegiance, and markers of identity. This cultural dimension adds layers of meaning to tattoos, connecting individual experiences to broader historical and social narratives. In contemporary society, this cultural richness continues to inform and inspire tattoo designs, making each piece a part of a larger artistic and cultural tapestry.

In addition to its personal and cultural significance, tattooing has gained recognition in the broader art world. Many tattoo artists are celebrated for their innovative techniques and contributions to the art form. Tattoo conventions and exhibitions provide platforms for artists to showcase their work, exchange ideas, and gain recognition within the artistic community. These events highlight the evolving nature of tattooing and its growing acceptance as a legitimate and respected art form.

In conclusion, tattooing is a multifaceted art form that encompasses personal expression, technical skill, and cultural significance. It transforms the human body into a canvas for storytelling and identity, creating artworks that are as unique and diverse as the individuals who wear them. As tattooing continues to evolve and gain recognition, it will undoubtedly remain a powerful medium for artistic and personal expression.

Setting Goals for the 30-Day Journey: What to Expect and How to Maximize the Benefits from This Guide

Embarking on a 30-day journey to master the basics and intermediate skills of tattooing is an exciting and transformative endeavor. This structured approach will help you develop a solid foundation, refine your techniques, and build confidence in your abilities. To make the most of this journey, it is essential to set clear, achievable goals and establish a disciplined practice routine. Here's what you can expect and how to maximize the benefits from this guide.

Understanding the Structure of the 30-Day Program

The 30-day program is designed to provide a comprehensive and immersive learning experience. Each day will focus on specific aspects of tattooing, gradually building your skills and knowledge. The program is divided into key areas, including design principles, technical execution, safety and hygiene, and developing your artistic style. By the end of the 30 days, you should have a well-rounded understanding of tattooing and a portfolio that showcases your progress.

Setting Achievable Goals

1. Daily Practice: Dedicate a set amount of time each day to practice. Consistency is crucial for skill development, and even short daily sessions can lead to significant improvements over time. Aim for at least one to two hours of focused practice each day.

2. Master Basic Techniques: Ensure that you have a firm grasp of fundamental techniques such as outlining, shading, and color application. These skills are the building blocks of tattooing, and mastering them will enable you to tackle more complex designs with confidence.

3. Develop Artistic Skills: Work on improving your drawing and design abilities. Spend time sketching, experimenting with different styles, and studying the work of established tattoo

artists. Developing a strong artistic foundation will enhance your tattoo designs and set you apart as an artist.

4. Safety and Hygiene: Prioritize learning and adhering to safety and hygiene practices. This includes understanding sterilization procedures, maintaining a clean workspace, and following best practices for client care. Ensuring a safe and sanitary environment is essential for both you and your clients.

5. Build a Portfolio: Document your progress by creating a portfolio of your work. Include sketches, practice pieces on synthetic skin, and tattoos on live models. A well-organized portfolio will showcase your growth and serve as a valuable tool for attracting clients and opportunities.

6. Seek Feedback: Engage with other tattoo artists and enthusiasts to receive constructive feedback on your work. Join online forums, attend workshops, and participate in tattoo conventions to connect with the community and gain insights from experienced practitioners.

Maximizing the Benefits of the Program

1. Stay Disciplined: Consistency and dedication are key to success. Stick to your daily practice routine and resist the temptation to skip days. Treat this journey as a commitment to yourself and your growth as an artist.

2. Reflect and Adjust: Take time to reflect on your progress regularly Identify areas where you excel and areas that need

improvement. Adjust your practice routine and goals accordingly to address any challenges and continue advancing.

3. Embrace Creativity: Allow yourself to experiment and explore different style s and techniques. Tattooing is an art form, and creativity is at its heart. Don't be afraid to push boundaries and develop your unique artistic voice.

4. Stay Informed: Keep up-to-date with industry trends, new techniques, and advancements in tattoo technology. Continuous learning will ensure that you remain at the forefront of the field and can offer your clients the best possible experience.

5. Build a Support Network: Surround yourself with supportive and like-minded individuals who share your passion for tattooing. A strong support network can provide encouragement, inspiration, and valuable advice throughout your journey.

By setting clear goals and maintaining a disciplined practice routine, you can maximize the benefits of this 30-day journey. Remember that mastery takes time and perseverance, and each step you take brings you closer to becoming a skilled and confident tattoo artist.

Chapter 2

Getting Started – Essential Tools and Equipment

"Every artist was first an amateur." - Ralph Waldo Emerson

The Backbone of Tattooing: Essential Tools and Equipment

Tattooing, like any art form, requires the right tools to achieve excellence. These tools are not just instruments; they are extensions of the artist's creativity and skill. For anyone serious about pursuing tattooing, understanding and investing in quality equipment is fundamental. This chapter delves into the essential tools and equipment that form the backbone of the tattooing process, ensuring both the artist's success and the client's safety.

Tattoo Machines: The Heart of the Craft

The tattoo machine is the most critical tool in a tattoo artist's arsenal. There are two primary types of tattoo machines: coil machines and rotary machines. Each has its unique characteristics and is suited for different aspects of tattooing.

Coil Machines: These are the traditional tattoo machines, characterized by their distinct buzzing sound. Coil machines use electromagnetic coils to move the needle groupings, creating the puncturing action. They are typically used for both lining and shading, with specific machines optimized for each task. Lining machines are designed to create clean, precise lines, while shading machines are configured to produce smooth gradients and fill in color.

Rotary Machines: Unlike coil machines, rotary machines use a motor to drive the needle. They are generally quieter and lighter, making them easier to handle, especially for long tattoo sessions. Rotary machines are versatile and can be used for

both lining and shading, though some artists prefer to have dedicated machines for each task.

Choosing between a coil and a rotary machine often comes down to personal preference and the specific needs of the artist. Both types have their strengths, and many professional tattoo artists use a combination of both to achieve the best results.

Needles and Needle Configurations

Tattoo needles are another crucial component of the tattooing process. They come in various configurations, each designed for a specific purpose. The three main types of needle groupings are liners, shaders, and magnums.

Liner Needles: These are used to create crisp, clean lines. They consist of a tight grouping of needles, arranged in a circular pattern. The number of needles in the grouping can vary, with smaller groupings used for fine lines and larger groupings for bold outlines.

Shader Needles: Shader needles are used to fill in color and create shading. They have a looser grouping than liner needles and are arranged in a circular or straight pattern. Shaders allow for smooth transitions between shades and are essential for achieving realistic effects.

Magnum Needles: Magnums are designed for large areas of shading and color packing. They are arranged in a flat or curved pattern, with the needles stacked in two rows. This

configuration allows for efficient ink deposition and reduces the trauma to the skin, making them ideal for extensive work.

Selecting the right needle configuration is vital for achieving the desired effect. Understanding how each type of needle interacts with the skin and the ink is crucial for producing high-quality tattoos.

Inks and Their Properties

Tattoo ink is another essential component, and its quality significantly impacts the final result. Tattoo inks are made from pigments combined with a carrier solution, usually a mixture of distilled water, alcohol, and glycerin. The pigments can be organic, inorganic, or synthetic, each offering different properties in terms of color and stability.

Black Ink: This is the most commonly used ink in tattooing. It is versatile and can be used for outlining, shading, and filling. High-quality black ink should have a rich, deep color and consistent flow.

Colored Inks: These are used to add vibrancy and depth to tattoos. Colored inks come in a wide range of hues, and their selection should be based on the desired effect and the client's skin tone. Quality colored inks should be bright, stable, and free from harmful substances.

White Ink: While not as commonly used as black or colored inks, white ink is essential for highlights and certain artistic effects. It requires careful application, as it can be more challenging to work with and may fade more quickly.

Choosing the Right Ink: When selecting tattoo ink, it is crucial to opt for reputable brands that adhere to safety standards. Poor-quality inks can cause allergic reactions, infections, and

premature fading. Always verify the ingredients and ensure that the inks are stored correctly to maintain their quality.

Workspace Setup: Creating an Optimal Environment

A well-organized workspace is fundamental for both the artist's efficiency and the client's comfort. The workspace should be clean, well-lit, and equipped with all necessary tools and supplies.

Tattoo Chair and Table: A comfortable, adjustable tattoo chair is essential for accommodating clients of different sizes and ensuring they remain still and relaxed during the tattoo process. An adjustable table or armrest can help position the area being tattooed for better access and precision.

Lighting: Proper lighting is critical for seeing fine details and ensuring accurate work. Adjustable, high-intensity lights with magnification options can enhance visibility and reduce eye strain.

Sterilization Equipment: Autoclaves are necessary for sterilizing reusable tools and equipment. They use high-pressure steam to kill bacteria and viruses, ensuring a sterile environment. Disposable items should be used whenever possible to minimize the risk of contamination.

Supply Organization: Keep all supplies, such as needles, inks, gloves, and cleaning materials, within easy reach. Use labeled containers and trays to maintain order and efficiency. A clutter-free workspace not only looks professional but also minimizes the risk of cross-contamination.

Safety and Hygiene Practices

Maintaining high standards of safety and hygiene is paramount in tattooing. Proper practices protect both the artist and the client from infections and complications.

Hand Hygiene: Always wash hands thoroughly before and after each tattoo session. Use antibacterial soap and follow with an alcohol-based hand sanitizer. Wearing disposable gloves during the tattoo process is mandatory to prevent the spread of pathogens.

Skin Preparation: Clean the client's skin with an antiseptic solution before starting the tattoo. Shave the area if necessary to remove hair, which can obstruct the tattooing process and harbor bacteria.

Equipment Sterilization: Sterilize all non-disposable tools using an autoclave. Ensure that needles, tubes, and grips are either disposable or sterilized between uses. Single-use items should be discarded immediately after the session.

Aftercare Instructions: Provide clients with detailed aftercare instructions to ensure proper healing and prevent infections. This includes advising on cleaning the tattoo, avoiding direct sunlight, and refraining from submerging the tattoo in water for extended periods.

Additional Tools and Supplies

In addition to the primary tools mentioned, several other supplies are essential for a successful tattooing practice.

Power Supply and Foot Pedal: A reliable power supply is crucial for consistent machine performance. The foot pedal allows the artist to control the machine hands-free, maintaining precision and focus.

Stencil Paper and Transfer Solution: Stencils help outline the design on the skin before tattooing. Transfer solutions ensure that the stencil adheres properly and remains visible throughout the process.

Ink Caps and Holders: These small containers hold individual portions of ink, preventing cross-contamination and ensuring that the artist has easy access to the necessary colors.

Razor and Shaving Gel: Used for preparing the skin by removing hair, ensuring a smooth surface for the tattoo.

Barrier Protection: Disposable barriers, such as machine bags and clip cord cover, protect equipment from ink splatters and bodily fluids, maintaining hygiene standards.

First Aid Supplies: Keep basic first aid supplies on hand, including bandages, antiseptic wipes, and burn ointment, to address any minor injuries or issues that may arise during the tattooing process.

Tattoo Machines and Needles: Types, Uses, and Maintenance

Tattoo Machines: Coil vs. Rotary

Tattoo machines are the cornerstone of any tattoo artist's toolkit, and understanding their types, uses, and maintenance is crucial for delivering high-quality work. There are two primary types of tattoo machines: coil machines and rotary machines, each with its distinct characteristics and applications.

Coil Machines: These machines are the traditional choice for many tattoo artists. They operate using electromagnetic coils to move the needle grouping. When the machine is powered, an electromagnetic current causes the coils to pull a spring-loaded armature bar, which in turn moves the needle. This rapid movement punctures the skin and deposits ink. Coil machines are generally louder and heavier, producing a distinctive buzzing sound. They are highly versatile, with specific machines designed for lining (creating clean, precise lines) and shading (producing smooth gradients and filling in color). Coil machines allow for significant customization, enabling artists to fine-tune their machines to their personal preferences and styles.

Rotary Machines: Rotary machines utilize a motor to drive the needle, resulting in a smoother and more consistent motion. They are typically quieter and lighter than coil machines, which can reduce hand fatigue during long tattoo sessions. Rotary machines are often praised for their versatility, as many models can be used for both lining and shading with minimal adjustments. The consistent motion of rotary machines can

also be gentler on the skin, potentially reducing healing time for clients. Additionally, rotary machines require less maintenance and are easier to use for beginners due to their straightforward mechanics.

Needle Configurations and Their Uses

Tattoo needles come in various configurations, each designed for specific tasks. Understanding these configurations is essential for achieving the desired effects in your tattoos.

Liner Needles: Liner needles are arranged in a tight circular formation, ideal for creating crisp, clean lines. The number of needles in a grouping can vary, with smaller groupings (e.g., 3RL or 5RL) used for fine lines and detailed work, and larger groupings (e.g., 9RL or 14RL) for bold outlines.

Shader Needles: Shader needles have a looser arrangement than liner needles, either in a circular or straight configuration. They are used for filling in color and creating gradients. Shader needles (e.g., 5RS or 7RS) allow for smooth transitions between shades and are essential for achieving realistic effects.

Magnum Needles: Magnum needles are designed for large areas of shading and color packing. They come in two primary configurations: flat (e.g., 7M1) and curved (e.g., 9CM). Flat magnums have a straight arrangement, while curved magnums are designed to follow the natural contours of the skin, reducing trauma and providing a more comfortable experience for the client.

Maintenance of Tattoo Machines and Needles

Proper maintenance of tattoo machines and needles is vital for ensuring their longevity and performance. Regular cleaning and upkeep prevent malfunctions and ensure a safe and hygienic environment for both the artist and the client.

Cleaning and Sterilization: After each use, tattoo machines should be thoroughly cleaned to remove ink, blood, and other contaminants. Disassemble the machine according to the manufacturer's instructions and clean each part with an appropriate cleaning solution. Autoclaving is essential for sterilizing reusable components, such as grips and tubes, to eliminate any potential pathogens. Single-use needles and cartridges should be disposed of immediately after use.

Lubrication: Regularly lubricate the moving parts of your tattoo machine, such as the armature bar and springs in coil machines, or the motor in rotary machines. Use a light machine oil or a product recommended by the machine's manufacturer. Proper lubrication reduces friction, prevents wear, and ensures smooth operation.

Calibration and Adjustment: Periodically check and adjust the tension and alignment of your tattoo machine to maintain optimal performance. For coil machines, this includes adjusting the contact screw, armature bar, and springs. Rotary machines generally require less adjustment, but it's still important to ensure that all components are functioning correctly. Regular calibration ensures consistent needle movement and prevents uneven or unreliable tattooing.

Needle Quality and Replacement: Always use high-quality needles from reputable suppliers. Inspect each needle before use to ensure there are no defects, such as bent or damaged

tips. Replace needles immediately if any issues are detected. Using damaged or poor-quality needles can result in subpar tattoos and increase the risk of injury or infection for clients.

Inks and Their Properties: Different Types of Inks and Their Applications

Tattoo inks are the lifeblood of the tattooing process, with their quality and properties significantly impacting the final outcome. Understanding the different types of inks and their applications is essential for any tattoo artist looking to create vibrant, long-lasting tattoos.

Composition of Tattoo Inks

Tattoo inks are composed of pigments and a carrier solution. The pigments provide the color, while the carrier solution keeps the pigment evenly distributed and prevents contamination. The carrier solution typically includes distilled water, alcohol, and glycerin, among other ingredients. It's crucial to use inks from reputable manufacturers to ensure they meet safety standards and do not contain harmful substances.

Types of Tattoo Inks

Black Ink: Black ink is the most versatile and widely used type of tattoo ink. It is essential for outlining, shading, and creating contrast in tattoos. High-quality black ink should have a rich, deep color and a consistent flow. Black ink is often made from

carbon-based pigments, which provide excellent coverage and longevity. Different brands may offer variations in viscosity and shade, allowing artists to choose the best black ink for their specific style and technique.

Colored Inks: Colored inks add vibrancy and depth to tattoos. These inks come in a wide range of hues, from primary colors to custom blends. The pigments in colored inks can be organic, inorganic, or synthetic, each offering different properties. Organic pigments, derived from natural sources, tend to be brighter and more vibrant but may fade faster. Inorganic pigments, such as those containing metal oxides, offer greater stability and longevity. Synthetic pigments are engineered to provide specific colors and properties, balancing vibrancy and durability.

White Ink: White ink is primarily used for highlights and certain artistic effects. It requires careful application, as it can be more challenging to work with and may fade more quickly than other colors. High-quality white ink should have a smooth consistency and be capable of creating crisp, bright highlights. White ink is also used in black-and-grey tattoos to add dimension and contrast.

UV and Glow-in-the-Dark Inks: UV inks, also known as blacklight inks, are visible under ultraviolet light but may be less noticeable under normal lighting conditions. These inks are popular for creating hidden designs that only appear under UV light. Glow-in-the-dark inks, on the other hand, absorb light and emit a glow in the dark. Both types of inks are typically used for special effects and require specific safety considerations, as some formulations may not be as thoroughly tested as traditional inks.

Applications of Tattoo Inks

Outlining: Black ink is predominantly used for outlining tattoos. The consistency and opacity of black ink make it ideal for creating clean, defined lines that form the foundation of the tattoo design. Outlining requires precise control and steady hands to ensure smooth, continuous lines.

Shading and Gradient Effects: Shading adds depth and dimension to tattoos, creating a sense of realism and texture. Black and grey inks are commonly used for shading, with different dilutions of black ink creating various shades of grey. Shading can be achieved using different techniques, such as stippling, hatching, and blending, to produce smooth transitions and realistic effects.

Color Packing: Colored inks are used to fill in large areas of the tattoo design, creating vibrant, solid blocks of color. This technique requires a thorough understanding of color theory and the properties of the inks being used. Artists must ensure even coverage and consistency to avoid patchiness and fading.

Highlighting: White ink is used to add highlights and enhance contrast in tattoos. It can make certain elements of the design stand out and create a three-dimensional effect. Applying white ink requires precision and a light touch, as it can easily become overpowering if not used correctly.

Choosing the Right Ink

Selecting the right ink is critical for achieving the desired results in a tattoo. Factors to consider include:

- **Skin Tone:** Different inks may appear differently depending on the client's skin tone. Testing inks on a small area can help determine how the color will look once healed.
- **Ink Consistency:** The viscosity and flow of the ink can affect how easily it is applied and how well it adheres to the skin. Thicker inks may provide better coverage but can be harder to work with, while thinner inks may flow more smoothly but require multiple passes for full coverage.
- **Color Stability:** Some inks are more prone to fading over time. Choosing inks with stable pigments can help ensure the tattoo retains its vibrancy for years to come.

Safety Considerations

Using safe, high-quality inks is paramount for protecting the health of clients. Always verify the ingredients of the inks and choose products from reputable manufacturers. Avoid inks that contain known allergens or harmful substances, such as heavy metals and carcinogens. Proper storage of inks, away from direct sunlight and extreme temperatures, can help maintain their quality and prevent contamination.

Workspace Setup: Creating a Clean, Organized, and Efficient Workspace

A well-designed workspace is fundamental for any tattoo artist, impacting both the quality of the work and the client's experience. Creating a clean, organized, and efficient environment enhances productivity and ensures safety. Here's a comprehensive guide to setting up the ideal tattoo workspace.

Layout and Organization

Ergonomics: The layout should prioritize ergonomics to prevent strain and fatigue during long tattoo sessions. Position the tattoo chair and artist's stool at adjustable heights to ensure comfort. The artist's workspace should allow for easy access to all tools without excessive reaching or bending.

Tattoo Chair and Table: Invest in a high-quality, adjustable tattoo chair that provides comfort and stability for the client. An adjustable armrest or table can help position different parts of the body for better access and precision.

Lighting: Proper lighting is crucial for visibility and precision. Use adjustable, high-intensity lights to illuminate the workspace without causing glare or shadows. A magnifying lamp can also be beneficial for detailed work.

Workstations: Set up workstations with all essential tools and supplies within easy reach. Use carts or trays to organize

needles, inks, gloves, and other supplies. Label containers and keep frequently used items in accessible locations to minimize downtime and maintain focus.

Cleanliness and Sterility

Surfaces: Use non-porous, easy-to-clean surfaces for all work areas. Stainless steel or medical-grade plastic tables and countertops are ideal. Cover work surfaces with disposable barriers that can be changed between clients to prevent cross-contamination.

- **Flooring:** Choose flooring that is easy to clean and disinfect, such as vinyl or tile. Avoid carpet, as it can harbor bacteria and be difficult to clean thoroughly.

- **Storage:** Keep storage areas clean and organized. Store sterilized equipment in sealed containers to maintain sterility. Separate clean and dirty supplies to prevent contamination.

- **Waste Disposal:** Set up designated areas for disposing of used needles, ink caps, and other waste. Use puncture-resistant, biohazard-labeled containers for sharps and follow local regulations for hazardous waste disposal.

Equipment Placement

Tattoo Machines: Place tattoo machines on stands or hooks to keep them off work surfaces when not in use. This helps maintain cleanliness and prevents accidental damage.

Power Supply: Position the power supply within easy reach of the tattoo machine, ensuring that cords are managed to avoid tripping hazards. Use foot pedals to control the machine without having to handle the power supply during the tattooing process.

Cleaning Supplies: Keep cleaning supplies, such as disinfectants, paper towels, and gloves, readily available. Use spray bottles for quick and efficient cleaning of surfaces between clients.

Personal Comfort

Seating: Ensure that both the artist and the client have comfortable seating. The artist's stool should be adjustable and provide adequate back support. The client's chair should be padded and adjustable to accommodate different body positions.

Climate Control: Maintain a comfortable temperature in the workspace. Use fans or heaters as needed to ensure a pleasant environment for both the artist and the client.

Music and Ambiance: Create a welcoming atmosphere with music or ambient sounds. This can help relax clients and create a positive experience. Keep the volume at a level that allows for clear communication.

Workflow Optimization

Pre-Session Preparation: Prepare all necessary tools and supplies before the client arrives. This includes setting up the tattoo machine, arranging inks, and preparing the stencil. Pre-session preparation reduces downtime and ensures a smooth workflow.

Post-Session Cleanup: Establish a routine for post-session cleanup. Clean and sterilize all reusable equipment, dispose of single-use items, and disinfect work surfaces. Keeping a clean workspace between sessions is essential for maintaining a professional environment.

Client Comfort: Provide clients with amenities such as water, blankets, and pillows to enhance their comfort. Encourage open communication to ensure that clients feel relaxed and informed throughout the tattoo process.

In summary, a well-organized, clean, and efficient workspace is essential for delivering high-quality tattoos and ensuring client satisfaction. Attention to detail in the setup and maintenance of the workspace fosters a professional environment that enhances the artist's productivity and the client's experience.

Safety and Hygiene Practices: Importance of Sterilization and Infection Prevention

Maintaining stringent safety and hygiene practices is paramount in tattooing. The process involves breaking the skin, making both the artist and the client susceptible to infections if proper protocols are not followed. Here's an in-depth guide to sterilization and infection prevention in a tattooing environment.

Hand Hygiene

Hand Washing: The foundation of infection control starts with hand hygiene. Wash hands thoroughly with antibacterial soap before and after each tattoo session, and after any activity that could contaminate hands. Use warm water and scrub all surfaces of the hands and wrists for at least 20 seconds.

Hand Sanitizer: Use an alcohol-based hand sanitizer with at least 60% alcohol content when soap and water are not available. This provides an additional layer of protection against germs.

Gloves: Always wear disposable gloves during the tattooing process. Change gloves between tasks to prevent cross-contamination, and never touch non-sterile surfaces with gloved hands.

Sterilization of Equipment

Autoclaving: An autoclave is essential for sterilizing reusable tools such as grips, tubes, and needles. Autoclaving uses high-pressure steam to kill bacteria, viruses, and spores. Follow the manufacturer's instructions for loading and running the autoclave, and regularly test its effectiveness using biological indicators.

Ultrasonic Cleaners: Before autoclaving, use an ultrasonic cleaner to remove ink, blood, and other debris from reusable tools. The ultrasonic cleaner uses high-frequency sound waves to dislodge contaminants, ensuring thorough cleaning.

Single-Use Items: Wherever possible, use single-use, disposable items such as needles, ink caps, and gloves. Dispose of these items immediately after use to prevent the spread of pathogens.

Cleaning Solutions: Use hospital-grade disinfectants to clean surfaces and equipment. Follow the manufacturer's guidelines for dilution and contact time to ensure effective disinfection. Regularly disinfect high-touch areas such as light switches, door handles, and workstation surfaces.

Skin Preparation

Antiseptic Solutions: Clean the client's skin with an antiseptic solution, such as alcohol or chlorhexidine, before starting the tattoo. This reduces the risk of introducing bacteria into the tattoo site.

Shaving: If necessary, shave the area to be tattooed using a single-use razor. Apply a thin layer of shaving gel to minimize skin irritation and ensure a smooth, clean surface.

Stencil Application: Use a transfer solution to apply the stencil. This solution should also have antiseptic properties to further reduce the risk of infection.

During the Tattoo Session

Barrier Protection: Use barrier protection such as machine bags, clip cord covers, and workstation covers to prevent contamination. These barriers should be replaced between clients.

Ink Management: Pour ink into single-use caps to avoid cross-contamination. Never return unused ink to the original container, as this can contaminate the entire supply.

Bloodborne Pathogen Training: Ensure that all artists and staff are trained in bloodborne pathogen protocols. This training covers the risks and prevention methods for diseases such as HIV, hepatitis B, and hepatitis C.

Aftercare Instructions

Client Education: Provide clients with detailed aftercare instructions to ensure proper healing and prevent infection. Instructions should include cleaning the tattoo with a mild soap, applying a suitable ointment, and avoiding activities that could introduce bacteria to the tattoo site, such as swimming.

Follow-Up: Encourage clients to contact you if they experience any signs of infection, such as excessive redness, swelling, or pus. Early intervention can prevent more serious complications.

Waste Disposa

Sharps Disposal: Dispose of needles and other sharp objects in a designated, puncture-resistant sharps container. Follow local regulations for the disposal of biohazardous waste.

General Waste: Dispose of non-sharp waste, such as gloves and paper towels, in sealed plastic bags. Ensure that these bags are removed from the workspace promptly to maintain a clean environment.

Regular Inspections and Audits

Internal Audits: Conduct regular internal audits of hygiene and safety practices to identify and address any areas of concern. Use a checklist to ensure all aspects of hygiene are covered.

Health Department Inspections: Comply with local health department regulations and inspections. Stay informed about any changes in regulations and update your practices accordingly.

Chapter 3

Skin and Anatomy

"The skin is a mirror that reflects the stories of our lives."

Understanding the Layers of the Skin

The skin is the largest organ of the human body, serving as a protective barrier and a canvas for tattoo artists. To create beautiful and lasting tattoos, it's essential to understand the skin's structure and how it interacts with tattooing. The skin consists of three primary layers: the epidermis, the dermis, and the hypodermis. Each layer plays a crucial role in the tattooing process.

Epidermis: The outermost layer of the skin, the epidermis, is composed of multiple layers of cells that provide a barrier against environmental damage. The stratum corneum, the outermost part of the epidermis, consists of dead skin cells that are continuously shed and replaced. This layer is crucial in protecting the underlying tissues but does not hold tattoo ink effectively, as the ink would be shed along with the dead cells.

Dermis: Beneath the epidermis lies the dermis, the layer that holds tattoo ink. The dermis is thicker and contains connective tissue, blood vessels, nerves, and hair follicles. The primary structure within the dermis that concerns tattoo artists is the collagen and elastin fibers, which provide strength and elasticity to the skin. When tattooing, the needle penetrates the

epidermis and deposits ink into the dermal layer. This placement ensures that the ink remains permanent, as the cells in the dermis do not shed like those in the epidermis.

Hypodermis: Also known as the subcutaneous layer, the hypodermis lies beneath the dermis. It consists of fat and connective tissue that insulates the body and provides cushioning. While the hypodermis is not directly involved in tattooing, understanding its presence helps in managing needle depth to avoid excessive trauma.

Skin Variations and Tattooing

Human skin varies significantly across different parts of the body and between individuals. Factors such as thickness, texture, and elasticity can influence how the skin reacts to tattooing and how the tattoo heals and ages over time.

Skin Thickness: The thickness of the skin varies depending on the body part. For example, the skin on the palms and soles is much thicker than the skin on the eyelids. Tattooing on thicker skin requires a more controlled technique to ensure that the ink is deposited at the correct depth. Conversely, tattooing on thinner skin requires a lighter touch to avoid excessive bleeding and scarring.

Skin Texture: Skin texture can also affect the tattooing process. Areas with rough or uneven skin, such as elbows and knees, can be more challenging to tattoo. The artist must adjust their technique to ensure even ink distribution and avoid patchiness. Smooth areas like the forearms and thighs are generally easier to tattoo and often heal more evenly.

Elasticity and Stretch: Skin elasticity refers to its ability to stretch and return to its original shape. This characteristic is influenced by factors such as age, hydration, and overall health. Elastic skin, commonly found in younger individuals, is more resilient to the trauma of tattooing and heals faster. Less elastic skin, often seen in older individuals, requires more careful handling to prevent tearing and prolonged healing.

The Healing Process

Understanding the healing process is crucial for both the tattoo artist and the client. Proper care during this period ensures the longevity and quality of the tattoo. The healing process can be divided into three main stages: inflammation, proliferation, and maturation.

Inflammation: The first stage begins immediately after the tattooing process and lasts for a few days. The skin responds to the trauma of tattooing with redness, swelling, and oozing of plasma. This stage is crucial for preventing infection. Clients should be advised to keep the area clean, apply a thin layer of ointment, and avoid touching or scratching the tattoo.

Proliferation: The second stage, which lasts from several days to a few weeks, involves the formation of new skin cells and blood vessels. Scabs and flakes may form as the epidermis regenerates. It's essential to keep the area moisturized and avoid picking at scabs, as this can lead to ink loss and scarring.

Maturation: The final stage of healing can last several months. During this time, the skin continues to strengthen, and the tattoo settles into the dermal layer. The tattoo may initially appear dull or cloudy, but it will become clearer and more vibrant as the skin fully heals.

Common Skin Conditions and Their Impact on Tattooing

Certain skin conditions can affect the tattooing process and the final outcome. Being aware of these conditions helps artists make informed decisions and provide appropriate care.

Acne: Tattooing over active acne can lead to uneven ink distribution and increased risk of infection. It is advisable to wait until the skin clears up before tattooing the affected area.

Eczema and Psoriasis: These conditions cause inflammation, dryness, and scaling of the skin. Tattooing over these areas can exacerbate the condition and lead to poor healing. It's essential to discuss the risks with clients and consider alternative locations for the tattoo.

Keloids: Some individuals are prone to keloid formation, where the skin produces excessive scar tissue. Tattooing can trigger keloid formation, leading to raised and distorted tattoos. Clients with a history of keloids should be informed of the risks, and a test tattoo in a less visible area may be advisable.

Hyperpigmentation and Hypopigmentation: Skin conditions that cause changes in pigmentation can affect how the tattoo appears. Hyperpigmentation results in darker patches of skin, while hypopigmentation leads to lighter areas. Tattooing over these areas requires careful color selection and technique to achieve a balanced appearance.

Tattooing Different Skin Types

Different skin types require tailored approaches to ensure optimal results and minimize complications.

Oily Skin: Oily skin can be more challenging to work with due to excess sebum, which can interfere with ink absorption. Thoroughly cleaning the area and using appropriate aftercare products can help manage this issue.

Dry Skin: Dry skin is prone to flaking and irritation. Proper hydration before and after the tattooing process is essential. Advise clients to use moisturizing lotions to prepare their skin and follow up with suitable aftercare.

Sensitive Skin: Sensitive skin is more reactive to the tattooing process, often resulting in more redness and swelling. Using hypoallergenic products and a gentler technique can help minimize discomfort and promote better healing.

Age-Related Skin Changes

As people age, their skin undergoes various changes that can impact tattooing.

Thinning Skin: Aging skin tends to become thinner and more fragile, making it more susceptible to injury during tattooing. A lighter touch and careful technique are necessary to avoid excessive trauma and ensure proper healing.

Loss of Elasticity: Reduced elasticity in older skin means it does not bounce back as easily. This can affect the precision of the tattoo and the healing process. Ensuring that the skin is well-stretched during tattooing can help achieve better results.

Slower Healing: Older skin heals more slowly, increasing the risk of infection and prolonged recovery. Providing detailed aftercare instructions and monitoring the healing process closely is crucial for older clients.

In conclusion, a comprehensive understanding of the skin's structure, variations, and healing processes is essential for any tattoo artist. By tailoring techniques to different skin types and conditions, artists can achieve beautiful, lasting tattoos while ensuring the health and safety of their clients.

Understanding Skin Layers: How Tattoos Interact with the Skin

To master the art of tattooing, it is crucial to understand how tattoos interact with the different layers of the skin. The skin consists of three primary layers: the epidermis, dermis, and hypodermis. Each layer plays a unique role in the tattooing process.

Epidermis: The epidermis is the outermost layer of the skin, composed mainly of keratinocytes, which are cells that provide a protective barrier. The stratum corneum, the topmost part of the epidermis, consists of dead cells that are continuously shed and replaced. When tattooing, the goal is to penetrate the epidermis without causing excessive damage, as the ink placed in this layer will be shed along with the dead cells. Proper technique ensures that the needle passes through the epidermis efficiently, minimizing trauma and discomfort.

Dermis: The dermis lies beneath the epidermis and is the primary target for tattoo ink. This layer is thicker and contains a dense network of collagen and elastin fibers, which provide structural integrity and elasticity to the skin. The dermis also houses blood vessels, nerves, and other structures essential for skin health. When tattooing, the needle deposits ink into the dermal layer, where it becomes encapsulated by fibroblasts. This encapsulation ensures that the ink remains stable and permanent. Proper depth control is crucial; too shallow and the ink will be lost during healing, too deep and it can cause excessive bleeding and scarring.

Hypodermis: Also known as the subcutaneous layer, the hypodermis consists mainly of fat and connective tissue. It provides insulation and cushioning for the body. While the hypodermis is not directly involved in the tattooing process, it is important to avoid penetrating this layer. Tattooing too deeply into the hypodermis can cause ink to disperse unevenly, leading to a distorted tattoo appearance and increased risk of infection.

Understanding these layers and their functions allows tattoo artists to apply their skills with precision. Knowledge of skin anatomy helps in adjusting techniques based on the client's skin type and location of the tattoo, ensuring optimal ink placement and longevity of the design.

Placement Considerations: Best Practices for Different Body Parts

Tattoo placement is a critical factor that influences the design, application, and longevity of a tattoo. Different body parts present unique challenges and opportunities, requiring tailored approaches for each area.

Arms and Legs: These are popular locations for tattoos due to their relatively flat surfaces and ample space. The skin on arms and legs tends to be more consistent in thickness, making it easier to achieve even ink distribution. However, areas with more muscle or fat, such as the upper arm or thigh, may

require adjustments in technique to ensure proper depth and consistency.

Back and Chest: The back and chest offer large canvases for extensive, detailed designs. The skin in these areas is generally thicker, allowing for more intricate work. However, the curvature of the body and the movement of underlying muscles can pose challenges. It's essential to account for skin movement and tension, especially over the shoulder blades or ribs, to prevent distortion.

Hands and Feet: Tattooing hands and feet requires specialized skills due to the unique properties of the skin in these areas. The skin on hands and feet is thicker and subject to more friction and wear, which can cause faster fading and blurring of the tattoo. Additionally, the presence of many small bones and tendons means careful attention to needle depth and pressure is necessary to avoid excessive pain and ensure proper healing.

Neck and Face: Tattoos on the neck and face are highly visible and often subject to more scrutiny. The skin in these areas is more delicate and has higher elasticity, which can affect ink retention and healing. Artists must use a lighter touch and be mindful of the client's comfort, as these areas are more sensitive and prone to swelling. Facial tattoos also have significant social implications, and clients should be fully aware of the permanence and visibility of their choices.

Stomach and Sides: The skin on the stomach and sides is typically softer and more pliable, which can affect tattooing precision. Stretching the skin adequately is crucial to achieve clean lines and even shading. The movement and expansion of these areas, especially due to weight changes or pregnancy, should be considered, as they can alter the appearance of the tattoo over time.

Ribs and Spine: Tattooing over the ribs and spine presents challenges due to the prominence of bones and the thinness of the skin. These areas can be more painful for the client, and achieving smooth, even lines can be difficult. Artists need to be particularly steady-handed and may need to adjust their techniques to accommodate the bony structure.

Proper placement considerations ensure that tattoos not only look good but also last longer and heal better. Each body part requires specific techniques and approaches, making knowledge of anatomy and skin behavior crucial for successful tattooing.

Healing Process: Stages of Healing and How to Advise Clients on Aftercare

The healing process of a tattoo is as important as the tattooing process itself. Proper aftercare ensures that the tattoo remains vibrant and free from infection. The healing process can be divided into three main stages: inflammation, proliferation, and maturation.

Inflammation: This initial stage begins immediately after the tattoo session and lasts for the first few days. The body's natural response to the trauma of tattooing includes redness, swelling, and tenderness around the tattooed area. Plasma, blood, and lymphatic fluids may ooze from the tattoo, forming a thin layer of scabbing. During this stage, it is crucial to keep the tattoo clean to prevent infection. Clients should wash the tattoo gently with lukewarm water and a mild, fragrance-free soap. After washing, they should pat the area dry with a clean paper towel and apply a thin layer of recommended ointment to keep the tattoo moist and protected.

Proliferation: The second stage of healing lasts from several days to a few weeks. During this time, new skin cells form and the tattoo begins to scab and peel. It is essential to advise clients not to pick or scratch the scabs, as this can lead to ink loss and scarring. Keeping the tattoo moisturized with a fragrance-free, hypoallergenic lotion helps manage itching and dryness. Clients should avoid soaking the tattoo in water, such as in baths or swimming pools, and should protect it from direct sunlight, which can cause fading.

Maturation: The final stage of healing can last several months. During maturation, the skin continues to regenerate and strengthen. The tattoo may appear dull or cloudy as the new skin forms over the ink, but it will gradually become clearer and more vibrant. Clients should continue to moisturize the tattoo and protect it from excessive sun exposure. Using a high-SPF sunscreen on the tattooed area helps preserve the colors and prevents sun damage.

Advising Clients on Aftercare

Providing clear and detailed aftercare instructions is essential for ensuring that the tattoo heals properly and maintains its quality. Here are some key points to include in aftercare advice:

1. **Cleaning:** Instruct clients to clean the tattoo gently twice a day with lukewarm water and mild, fragrance-free soap. They should avoid using abrasive materials or harsh chemicals.
2. **Moisturizing:** Recommend a suitable ointment or lotion to keep the tattoo moisturized. Emphasize the importance of applying only a thin layer to avoid suffocating the skin.
3. **Avoiding Irritants:** Advise clients to avoid activities that could expose the tattoo to bacteria, dirt, or excessive moisture. This includes swimming, using saunas, and engaging in strenuous activities that cause heavy sweating.
4. **Sun Protection:** Emphasize the importance of protecting the tattoo from the sun. Recommend using a high-SPF sunscreen once the tattoo is fully healed to prevent fading and sun damage.
5. **Monitoring for Infection:** Educate clients on the signs of infection, such as excessive redness, swelling, pus, or fever. Advise them to seek medical attention if they suspect an infection.
6. **Avoiding Tight Clothing:** Suggest wearing loose, breathable clothing to avoid irritation and friction on the new tattoo.
7. **Patience:** Remind clients that healing is a gradual process and that proper aftercare is crucial for achieving the best

results. Encourage them to follow the aftercare routine diligently and to contact you if they have any concerns or questions.

By providing thorough aftercare instructions and supporting clients through the healing process, tattoo artists can ensure that their work heals beautifully and remains a source of pride for both the artist and the client.

Chapter 4

Designing Tattoos

"Creativity takes courage." - Henri Matisse

The Art and Science of Tattoo Design

Designing tattoos is a delicate balance between art and science. It requires a blend of creativity, technical skill, and an understanding of human anatomy. A well-designed tattoo not only looks beautiful but also complements the natural contours of the body, ages gracefully, and holds personal significance for the wearer.

Understanding Tattoo Design Principles

The foundation of any successful tattoo lies in its design principles. These principles guide the artist in creating visually appealing and meaningful tattoos.

Balance: Balance in tattoo design refers to the distribution of visual weight across the composition. There are two types of balance: symmetrical and asymmetrical. Symmetrical balance involves mirroring elements on either side of a central axis, creating a harmonious and orderly look. Asymmetrical balance, on the other hand, involves arranging elements of varying

sizes, shapes, and colors in a way that still achieves visual equilibrium. Both approaches can be effective, depending on the desired aesthetic.

Contrast: Contrast is the use of opposing elements, such as light and dark, large and small, or rough and smooth, to create visual interest and depth. High contrast can make a tattoo more striking and easier to read from a distance. Incorporating contrast in shading, line thickness, and color choices enhances the overall impact of the design.

Proportion: Proportion refers to the relative size and scale of the elements within a design. Maintaining proper proportion ensures that the tattoo fits well with the body's natural anatomy and looks cohesive. Disproportionate elements can disrupt the harmony of the design and make it appear awkward or unbalanced.

Flow and Movement: A tattoo should flow naturally with the contours of the body. Lines and shapes should guide the viewer's eye smoothly across the design, creating a sense of movement and dynamism. This is especially important for larger tattoos that cover significant areas of the body. Effective use of flow can enhance the aesthetic appeal and longevity of the tattoo.

Unity and Harmony: Unity and harmony are achieved when all elements of the design work together cohesively. This involves consistent use of style, color, and technique

throughout the tattoo. A unified design appears intentional and well-thought-out, enhancing the overall quality of the artwork.

Drawing and Sketching Techniques

Effective tattoo design begins with strong drawing and sketching techniques. These skills are essential for translating ideas into tangible designs that can be successfully tattooed.

Freehand Drawing: Freehand drawing allows for more spontaneity and creativity. This technique is particularly useful for creating custom designs that fit the client's body shape and size. Practicing freehand drawing helps artists develop their personal style and improve their ability to visualize and execute complex designs.

Using Reference Materials: Reference materials, such as photographs, artwork, and anatomical diagrams, are invaluable tools for tattoo artists. They provide inspiration and ensure accuracy in depicting subjects like animals, portraits, and landscapes. Combining multiple references can lead to unique and innovative designs.

Stencil Creation: Stencils are an essential part of the tattooing process, providing a precise outline for the tattoo. Creating a stencil involves transferring the final design onto transfer paper using a thermal copier or by hand. The stencil ensures consistency and accuracy, especially for intricate or detailed designs.

Digital Tools: Digital tools and software, such as Adobe Photoshop and Procreate, have become increasingly popular for tattoo design. These tools allow artists to create and manipulate designs easily, experiment with different compositions, and preview how the tattoo will look on the client's body. Digital tools also facilitate collaboration with clients, enabling quick adjustments and refinements based on feedback.

Custom Designs and Client Collaboration

Creating custom designs is a significant aspect of tattoo artistry. Custom tattoos are tailored to the client's preferences, ensuring that each piece is unique and meaningful.

Consultation Process: The consultation process is the first step in creating a custom design. During this meeting, the artist discusses the client's ideas, preferences, and any specific symbols or themes they want to incorporate. Understanding the client's vision is crucial for creating a design that resonates with them on a personal level.

Concept Development: After the initial consultation, the artist begins developing concepts based on the client's input. This stage involves brainstorming, sketching rough ideas, and exploring different styles and compositions. The goal is to create a variety of options that reflect the client's vision while showcasing the artist's creativity.

Client Feedback and Revisions: Collaboration with the client continues throughout the design process. Presenting initial concepts and gathering feedback ensures that the final design

meets the client's expectations. Revisions may involve adjusting elements, refining details, or incorporating new ideas. Open communication and flexibility are key to achieving a successful outcome.

Finalizing the Design: Once the client approves the concept, the artist finalizes the design, adding details, shading, and color. The final design should be clear, well-defined, and ready for stencil creation. Ensuring that the client is completely satisfied with the design before the tattooing process begins is crucial for both the artist and the client.

Exploring Different Tattoo Styles

Tattoo artistry encompasses a wide range of styles, each with its unique characteristics and techniques. Understanding these styles allows artists to expand their repertoire and cater to diverse client preferences.

Traditional: Traditional tattoos, also known as American Traditional, are characterized by bold lines, vibrant colors, and iconic imagery such as anchors, roses, and eagles. This style is rooted in the early days of Western tattooing and remains popular for its timeless appeal and durability.

Neo-Traditional: Neo-Traditional tattoos build on the traditional style by incorporating more intricate details, a broader color palette, and elements of realism. This style

allows for greater artistic expression while maintaining the bold, clean lines that define traditional tattoos.

Realism: Realism tattoos aim to create lifelike representations of subjects, whether they are portraits, animals, or objects. This style requires a high level of technical skill and attention to detail. Realism tattoos often use subtle shading and gradients to achieve a three-dimensional effect.

Blackwork: Blackwork tattoos use only black ink to create striking, high-contrast designs. This style includes a variety of techniques such as line work, dotwork, and geometric patterns. Blackwork tattoos can range from minimalist designs to complex, full-body compositions.

Watercolor: Watercolor tattoos mimic the appearance of watercolor paintings, using soft, flowing colors and abstract shapes. This style is known for its delicate and ethereal quality. Achieving the watercolor effect requires a careful balance of color blending and negative space.

Japanese: Japanese tattoos, or Irezumi, are rich in symbolism and tradition. This style features intricate designs that often include mythical creatures, samurai, and nature motifs. Japanese tattoos are typically large-scale, covering significant portions of the body, and use a combination of bold outlines and detailed shading.

New School: New School tattoos are characterized by their exaggerated features, vibrant colors, and cartoonish style. This playful and imaginative style allows for a high degree of creativity and often incorporates elements of graffiti and pop culture.

Incorporating Symbolism and Meaning

Many clients choose tattoos that hold personal significance or represent important aspects of their lives. Understanding and incorporating symbolism into designs adds depth and meaning to the artwork.

Cultural Symbols: Different cultures have unique symbols and motifs that carry specific meanings. Researching and understanding these symbols ensures that they are used appropriately and respectfully. For example, lotus flowers in Asian cultures symbolize purity and enlightenment, while skulls in Mexican culture can represent the celebration of life and remembrance of the deceased.

Personal Symbols: Personal symbols can include anything from names and dates to images that represent significant experiences or beliefs. Working closely with clients to identify these symbols and integrate them into the design creates a tattoo that is deeply meaningful and personal.

Abstract Symbols: Abstract symbols, such as geometric shapes and patterns, can also convey meaning. These elements can represent concepts like balance, harmony, and infinity.

Abstract symbols can be used alone or combined with other elements to create a unique and symbolic design.

In conclusion, designing tattoos is a multifaceted process that requires a deep understanding of artistic principles, technical skills, and client collaboration. By mastering these elements, tattoo artists can create beautiful, meaningful, and lasting works of art that reflect their clients' unique stories and visions.

Fundamentals of Tattoo Design: Basic Principles of Creating Visually Appealing Designs

Creating visually appealing tattoo designs involves understanding and applying fundamental design principles. These principles guide artists in composing tattoos that are not only aesthetically pleasing but also harmonious and meaningful.

Balance: Achieving balance in a tattoo design ensures that no single part of the tattoo overwhelms the others. There are two main types of balance: symmetrical and asymmetrical. Symmetrical balance involves mirroring elements on either side of a central axis, creating a sense of order and stability. Asymmetrical balance, while more dynamic, still requires an even distribution of visual weight to maintain harmony. Both types of balance are useful depending on the design's intent and the client's preference.

Contrast: Contrast is essential for creating visual interest and depth. It involves using opposing elements, such as light and dark, thick and thin lines, or different textures. High contrast can make a tattoo more striking and easier to read from a distance. Effective use of contrast can enhance the design's details and bring attention to key elements, making the tattoo more engaging.

Proportion: Proportion refers to the size relationship between different parts of the design. Proper proportion ensures that all elements of the tattoo work together cohesively. Disproportionate elements can make a design look awkward or unbalanced. Understanding human anatomy helps in creating designs that fit well on the body and move naturally with it.

Flow and Movement: A well-designed tattoo should flow naturally with the body's contours. Lines and shapes should guide the viewer's eye smoothly across the design, creating a sense of movement. This is particularly important for larger tattoos that cover significant areas of the body. Good flow can enhance the tattoo's overall aesthetic and longevity.

Unity and Harmony: Unity and harmony are achieved when all parts of the design work together as a whole. This involves consistent use of style, color, and technique. A unified design looks intentional and well-thought-out, enhancing the tattoo's overall quality. Ensuring that every element fits seamlessly into the design prevents it from looking disjointed.

Color Theory: Understanding color theory is crucial for creating vibrant and harmonious tattoos. This includes knowledge of primary, secondary, and tertiary colors, as well as how they interact. Complementary colors, which are opposite each other on the color wheel, can create striking contrasts. Analogous colors, which are next to each other on the color wheel, provide harmony and are pleasing to the eye. Effective color use can enhance the design's impact and ensure it ages well.

Line Quality: Lines are the foundation of most tattoo designs. The quality of lines—whether they are thick, thin, smooth, or textured—affects the overall look of the tattoo. Consistent, clean lines contribute to a professional appearance. Varying line thickness can add depth and interest to the design.

By mastering these fundamental principles, tattoo artists can create designs that are both visually appealing and technically sound. Understanding and applying these basics ensures that each tattoo not only looks great but also stands the test of time.

Drawing and Sketching Techniques: Improving Your Freehand Skills

Improving freehand drawing and sketching skills is essential for any tattoo artist. These skills form the foundation of creativity and precision in tattoo design. Here are key techniques to enhance your freehand abilities.

Observational Drawing: Observational drawing involves sketching real-life objects and scenes. This practice sharpens

your ability to capture details and understand forms. Spend time drawing a variety of subjects, from still life arrangements to human figures. Focus on proportions, light, shadow, and textures. The more you practice, the better you become at translating three-dimensional objects onto a two-dimensional surface.

Gesture Drawing: Gesture drawing is a technique used to capture the essence and movement of a subject quickly. It involves making rapid, loose sketches that emphasize the action and flow rather than details. This practice helps in developing a sense of movement and energy in your drawings. Spend a few minutes each day doing quick gesture sketches to enhance your ability to capture dynamic poses and compositions.

Contour Drawing: Contour drawing focuses on the edges and outlines of a subject. This technique helps in understanding shapes and improving hand-eye coordination. Blind contour drawing, where you draw the outline of a subject without looking at your paper, can be particularly effective. It trains your eyes to follow the object's contours closely, improving accuracy and confidence in your line work.

Anatomy Studies: Understanding human anatomy is crucial for tattoo artists, especially for designing tattoos that fit well on the body. Study anatomical diagrams and practice drawing muscles, bones, and body parts. This knowledge helps in creating realistic and proportionate designs that move

naturally with the body. Pay attention to how different body parts interact and how they change in various positions.

Shading Techniques: Mastering shading techniques is essential for adding depth and dimension to your designs. Practice different shading methods such as hatching, cross-hatching, stippling, and blending. Experiment with light and shadow to create realistic effects. Understanding how light interacts with different surfaces helps in creating convincing and visually appealing tattoos.

Composition and Layout: Effective composition is about arranging elements in a way that is aesthetically pleasing and balanced. Practice different layout techniques, such as the rule of thirds, symmetry, and radial balance. Sketching thumbnail layouts can help in experimenting with various compositions quickly. This practice enhances your ability to create cohesive and dynamic designs.

Using Reference Materials: Reference materials are invaluable for improving your drawing skills. Use photos, anatomical models, and other artists' work as references. Study how experienced artists handle various subjects and techniques. However, always strive to add your unique touch and avoid direct copying.

Consistency and Routine: Improvement comes with consistent practice. Set aside dedicated time each day for drawing and sketching. Keeping a sketchbook allows you to track your progress and experiment freely. Challenge yourself

with new subjects and techniques regularly to push your boundaries and expand your skill set.

By incorporating these techniques into your practice routine, you can significantly enhance your freehand drawing and sketching skills. These abilities are crucial for creating original, high-quality tattoo designs that resonate with clients and showcase your artistic talent.

Digital Design Tools: Utilizing Software for Tattoo Design

In the modern tattoo industry, digital design tools have become invaluable for creating detailed and precise tattoo designs. These tools offer a range of features that streamline the design process and enhance creativity. Here's a comprehensive look at utilizing software for tattoo design.

Advantages of Digital Tools: Digital design tools provide several advantages over traditional methods. They allow for easy adjustments, precise detailing, and quick revisions. Artists can experiment with different styles, colors, and compositions without committing to a final design. Additionally, digital tools facilitate collaboration with clients, enabling real-time feedback and modifications.

Popular Software: Several software programs are popular among tattoo artists. Adobe Photoshop and Illustrator are industry standards, known for their robust features and versatility. Photoshop is excellent for creating detailed, layered designs and photo manipulation, while Illustrator is ideal for

vector-based graphics and clean lines. Procreate, an app for the iPad, has also gained popularity for its user-friendly interface and powerful drawing capabilities.

Digital Drawing Techniques: Learning digital drawing techniques is essential for making the most of these tools. Understanding layers is fundamental; they allow you to separate different elements of your design, making it easier to edit specific parts without affecting the whole image. Utilize the brush tool for various effects, such as shading, texturing, and detailing. Custom brushes can replicate traditional tattoo styles like stippling, hatching, and watercolor effects.

Creating Stencils: Digital tools are particularly useful for creating precise stencils. Start by outlining your design in a separate layer using a high-contrast color. This layer will serve as your stencil. Use the pen tool in Illustrator or the brush tool in Photoshop to create clean, smooth lines. Once the outline is complete, invert the colors to create a high-contrast stencil that can be printed and transferred to the client's skin.

Color Theory and Application: Digital tools allow for extensive experimentation with color. Use the color wheel and swatch libraries to explore different color schemes and combinations. Digital platforms enable you to see how different colors interact and to adjust hues, saturation, and brightness easily. This experimentation helps in creating harmonious and vibrant tattoo designs.

Texturing and Shading: Texturing and shading add depth and realism to your digital designs. Use different brushes and techniques to mimic traditional tattoo shading methods. For example, use a soft round brush for smooth gradients or a stippling brush for dot shading. Experiment with layer blending modes to achieve various effects, such as overlaying textures or enhancing contrast.

Photo Integration: Incorporating photos into your designs can add realism and detail. Use high-resolution images and integrate them seamlessly into your artwork. Photoshop's blending and masking tools allow you to combine photos with digital drawings effectively. This technique is especially useful for creating realistic portraits and intricate designs.

Collaboration and Client Feedback: Digital tools facilitate easy collaboration with clients. Share your designs electronically, allowing clients to review and provide feedback. Use software features like comments and annotations to communicate changes and suggestions. This interactive process ensures that the final design aligns with the client's vision and expectations.

Exporting and Printing: Once the design is complete, export it in a high-resolution format suitable for printing. Common formats include PNG, JPEG, and PDF. Ensure that the resolution is set to at least 300 dpi to maintain clarity and detail. Print the design to create a stencil or to provide the client with a detailed preview of the final tattoo.

By mastering digital design tools, tattoo artists can enhance their creative process, improve efficiency, and deliver high-quality designs that meet client expectations. These tools are invaluable for modern tattoo artistry, offering endless possibilities for innovation and precision.

Creating Custom Designs: Working with Clients to Develop Unique, Personalized Tattoos

Creating custom tattoo designs is a collaborative process that combines the artist's expertise with the client's vision. This partnership ensures that each tattoo is unique and personally significant. Here's how to effectively work with clients to develop personalized tattoos.

Initial Consultation: The initial consultation is a crucial step in understanding the client's ideas and preferences. During this meeting, discuss the client's vision, including the theme, style, and elements they want in the tattoo. Ask about any symbolic meanings or personal stories they want to incorporate. Taking detailed notes helps in capturing the essence of their ideas.

Research and Inspiration: After the consultation, conduct research to gather inspiration and references. Look into relevant symbols, cultural motifs, and artistic styles that align with the client's vision. Creating a mood board with images, sketches, and color schemes can help visualize the concept and serve as a reference throughout the design process.

Concept Development: Begin by sketching rough concepts based on the consultation and research. Create several variations to explore different compositions and elements. This stage is about brainstorming and experimenting with ideas.

Share these initial sketches with the client to gather feedback and refine the concept further.

Client Feedback and Revisions: Collaboration with the client continues as you refine the design. Present the initial concepts and discuss any adjustments or new ideas they might have. Encourage open communication and be receptive to their suggestions. Make revisions based on the feedback, focusing on details and elements that resonate with the client. This iterative process ensures that the final design reflects their vision accurately.

Finalizing the Design: Once the client approves the concept, proceed with finalizing the design. Add intricate details, shading, and color, ensuring that the design is cohesive and balanced. Pay attention to how the design will fit on the client's body, considering the natural contours and movement of the skin. Ensure that the final artwork is clear and precise, ready for stencil creation.

Presentation and Approval: Present the finalized design to the client for approval. Provide a detailed explanation of the design elements and how they align with their vision. Show the design from different angles and how it will fit on their body. Address any last-minute changes or concerns to ensure the client is completely satisfied.

Creating the Stencil: Transfer the final design onto stencil paper using a thermal copier or by hand. The stencil provides a precise outline that guides the tattooing process. Ensure that the stencil is clear and accurate, capturing all essential details. Test the stencil on the client's skin to verify placement and make any necessary adjustments.

Tattoo Session Preparation: Prepare for the tattoo session by setting up a clean and organized workspace. Arrange all necessary tools and materials within easy reach. Brief the client on what to expect during the session, including the duration, pain levels, and aftercare instructions. Maintaining open communication throughout the session helps keep the client comfortable and informed.

Aftercare Instructions: Provide detailed aftercare instructions to ensure proper healing and preservation of the tattoo. Explain the importance of keeping the tattoo clean, moisturized, and protected from sun exposure. Advise the client on what to avoid, such as scratching, soaking, or exposing the tattoo to harsh chemicals. Follow-up with the client to monitor the healing process and address any concerns.

Building Long-Term Relationships: Developing a strong rapport with clients can lead to long-term relationships and repeat business. Encourage clients to return for touch-ups or additional tattoos. Maintain a professional and friendly demeanor, ensuring that each client feels valued and respected.

Positive experiences lead to word-of-mouth referrals, which are invaluable for building a successful tattoo business.

By following these steps, tattoo artists can create custom designs that are unique, meaningful, and tailored to the client's preferences. This collaborative approach ensures that each tattoo is a work of art that the client will cherish for a lifetime.

Chapter 5

Tattoo Styles and Techniques

"A tattoo is an affirmation: that this body is yours to have and to enjoy while you're here." - Don Ed Hardy

The Diverse World of Tattoo Styles

Tattoo artistry is a rich and diverse field, encompassing a wide array of styles and techniques. Each style has its unique characteristics, cultural origins, and methods, offering tattoo artists and clients countless possibilities for self-expression. Understanding these styles and mastering the techniques associated with them is essential for any tattoo artist aiming to create high-quality, personalized work.

Traditional (Old School): Traditional tattoos, also known as Old School tattoos, are characterized by their bold lines, vibrant colors, and iconic imagery. Common motifs include anchors, roses, skulls, and nautical themes. This style, rooted in the early days of Western tattooing, is known for its simplicity, durability, and timeless appeal. The use of solid black outlines and a limited color palette ensures that these tattoos age well, maintaining their clarity and impact over time.

Neo-Traditional: Neo-Traditional tattoos build upon the foundations of Traditional style but incorporate more intricate

details, a broader color palette, and elements of realism. This style allows for greater artistic expression while maintaining the bold, clean lines that define Traditional tattoos. Neo-Traditional tattoos often feature elaborate compositions with ornate patterns, natural elements, and a mix of realistic and fantastical subjects.

Realism: Realism tattoos aim to create lifelike representations of subjects, whether they are portraits, animals, or objects. This style requires a high level of technical skill and attention to detail. Realism tattoos often use subtle shading and gradients to achieve a three-dimensional effect, making the artwork appear as though it is a photograph on the skin. This style is particularly popular for memorial tattoos and detailed portraiture.

Blackwork: Blackwork tattoos use only black ink to create striking, high-contrast designs. This style includes a variety of techniques such as line work, dotwork, and geometric patterns. Blackwork tattoos can range from minimalist designs to complex, full-body compositions. The focus on black ink allows for bold and dramatic results, with intricate details and patterns creating depth and texture.

Watercolor: Watercolor tattoos mimic the appearance of watercolor paintings, using soft, flowing colors and abstract shapes. This style is known for its delicate and ethereal quality. Achieving the watercolor effect requires a careful balance of color blending and negative space. Watercolor tattoos often

incorporate splashes of color that appear to bleed into the skin, creating a dreamy and fluid aesthetic.

Japanese (Irezumi): Japanese tattoos, or Irezumi, are rich in symbolism and tradition. This style features intricate designs that often include mythical creatures, samurai, and nature motifs such as koi fish, cherry blossoms, and waves. Japanese tattoos are typically large-scale, covering significant portions of the body, and use a combination of bold outlines and detailed shading. The themes and imagery are deeply rooted in Japanese culture and folklore, adding layers of meaning to the artwork.

New School: New School tattoos are characterized by their exaggerated features, vibrant colors, and cartoonish style. This playful and imaginative style allows for a high degree of creativity and often incorporates elements of graffiti and pop culture. New School tattoos are known for their bold, dynamic compositions and exaggerated perspectives, creating a sense of movement and energy.

Dotwork: Dotwork tattoos are created using a series of small dots to form intricate patterns and images. This technique can be used to create both abstract designs and detailed illustrations. Dotwork requires precision and patience, as the artist must carefully place each dot to achieve the desired effect. This style is often used for geometric patterns, mandalas, and shading in Blackwork tattoos.

Geometric: Geometric tattoos focus on the use of shapes and lines to create patterns and designs. These tattoos often feature symmetrical and repetitive elements, resulting in visually striking compositions. Geometric tattoos can be purely abstract or incorporate recognizable forms such as animals or objects. The precision and symmetry required for this style demand a high level of technical skill and attention to detail.

Techniques for Mastering Tattoo Styles

To excel in various tattoo styles, artists must master specific techniques and continuously refine their skills. Here are key techniques associated with different styles and how to develop proficiency in them.

Bold Lining and Solid Coloring: For Traditional and Neo-Traditional tattoos, bold lining and solid coloring are essential. Practice using different needle configurations to achieve thick, consistent lines. Solid coloring requires smooth, even application of ink without patchiness. Working on synthetic skin or practice sheets can help refine these skills.

Shading and Blending: Realism and Watercolor tattoos rely heavily on effective shading and blending techniques. Use different needle groupings, such as magnums and shaders, to create smooth gradients and realistic textures. Experiment with varying pressure and speed to achieve subtle transitions between light and dark areas.

Dot Placement and Precision: Dotwork and Geometric tattoos demand precise dot placement and consistency. Practice creating even, uniform dots with a single needle or fine liner. Consistent hand pressure and steady motion are crucial for achieving clean, detailed patterns. Working on smaller sections at a time helps maintain accuracy and focus.

Dynamic Composition and Color Theory: New School tattoos benefit from dynamic composition and a strong understanding of color theory. Study the use of complementary and contrasting colors to create vibrant, eye-catching designs. Experiment with exaggerated perspectives and bold outlines to add depth and movement to your artwork.

Symbolism and Cultural Context: Japanese tattoos require knowledge of cultural symbolism and context. Study traditional Japanese art and folklore to understand the meanings behind common motifs. Practice incorporating these elements into cohesive, large-scale designs that flow naturally with the body's contours.

Freehand and Customization: Custom and Freehand tattoos involve creating unique, personalized designs directly on the client's skin. Develop strong freehand drawing skills by practicing regularly and working from references. This technique allows for greater flexibility and adaptation to the client's body, ensuring a perfect fit.

Digital Design and Stenciling: Utilize digital design tools to create detailed, precise stencils for complex tattoos. Software like Photoshop and Procreate can help refine designs, experiment with colors, and ensure accurate proportions. Mastering digital tools enhances efficiency and allows for easy adjustments based on client feedback.

Continuous Learning and Adaptation: Tattooing is an ever-evolving art form. Stay updated with new trends, techniques, and technologies by attending workshops, conventions, and networking with other artists. Continuously challenge yourself to experiment with different styles and push the boundaries of your creativity.

Traditional vs. Modern Styles: Exploring Various Tattoo Styles

The evolution of tattoo styles reflects the dynamic nature of art and culture. Traditional and modern tattoo styles each offer distinct aesthetics and techniques, providing artists with a broad spectrum of creative possibilities.

Traditional (Old School) Tattoos: Traditional tattoos are rooted in the early days of Western tattooing, particularly among sailors and military personnel. This style is characterized by bold black outlines, a limited but vibrant color palette, and iconic imagery such as anchors, roses, and skulls. The designs are straightforward and easily recognizable, focusing on simplicity and durability. The thick lines and solid

colors ensure that the tattoos age well, maintaining their clarity over time.

Neo-Traditional Tattoos: Neo-Traditional tattoos build on the foundations of Traditional style but incorporate more intricate details, a broader color palette, and elements of realism. This style retains the bold lines and iconic imagery but adds depth and complexity through shading, texture, and elaborate compositions. Neo-Traditional tattoos often feature natural elements, such as animals and flowers, rendered with greater detail and artistic flair.

Realism: Realism tattoos aim to create lifelike representations of subjects, whether they are portraits, animals, or objects. This style requires a high level of technical skill and attention to detail. Realism tattoos often use subtle shading and gradients to achieve a three-dimensional effect, making the artwork appear as though it is a photograph on the skin. This style is particularly popular for memorial tattoos and detailed portraiture, capturing the essence of the subject with precision.

Abstract Tattoos: Abstract tattoos depart from traditional imagery and realism, focusing instead on shapes, colors, and lines to convey emotion and meaning. This style allows for a high degree of artistic freedom, often resulting in unique and unconventional designs. Abstract tattoos can be entirely non-representational or incorporate elements of recognizable forms in a stylized manner. The emphasis is on creativity and personal expression, making each piece a distinctive work of art.

Geometric Tattoos: Geometric tattoos focus on the use of shapes and lines to create patterns and designs. These tattoos often feature symmetrical and repetitive elements, resulting in visually striking compositions. Geometric tattoos can be purely abstract or incorporate recognizable forms such as animals or objects. The precision and symmetry required for this style demand a high level of technical skill and attention to detail.

New School: New School tattoos are characterized by their exaggerated features, vibrant colors, and cartoonish style. This playful and imaginative style allows for a high degree of creativity and often incorporates elements of graffiti and pop culture. New School tattoos are known for their bold, dynamic compositions and exaggerated perspectives, creating a sense of movement and energy.

Japanese (Irezumi): Japanese tattoos, or Irezumi, are rich in symbolism and tradition. This style features intricate designs that often include mythical creatures, samurai, and nature motifs such as koi fish, cherry blossoms, and waves. Japanese tattoos are typically large-scale, covering significant portions of the body, and use a combination of bold outlines and detailed shading. The themes and imagery are deeply rooted in Japanese culture and folklore, adding layers of meaning to the artwork.

Each of these styles offers unique opportunities for expression and creativity, allowing tattoo artists to develop their own distinct approach and cater to diverse client preferences. Mastery of various styles enhances an artist's versatility and

ability to create custom, personalized tattoos that resonate with their clients.

Line Work and Shading Techniques: Mastering the Basics of Lines and Shading

Mastering line work and shading is fundamental to creating high-quality tattoos. These techniques form the backbone of tattoo artistry, influencing the overall look, depth, and texture of the design.

Line Work: Line work involves creating the outlines and defining elements of a tattoo. Clean, consistent lines are crucial for a professional appearance. Here are key aspects to focus on:

Consistency: Consistency in line weight and smoothness is essential. Practice using different needle configurations to achieve varying line thicknesses. A steady hand and controlled machine speed help maintain uniformity.

Pressure: Apply consistent pressure to avoid uneven lines. Too much pressure can cause blowouts (ink spreading under the skin), while too little can result in faint, incomplete lines. Find the right balance through practice and experience.

Flow: Ensure that lines flow naturally with the design and the body's contours. Avoid abrupt changes in direction that can disrupt the harmony of the tattoo. Smooth, continuous strokes are preferable.

Overlapping Lines: When lines overlap or intersect, maintain clarity and precision. Overlapping lines should be clean and distinct to avoid confusion and muddiness in the design.

Shading Techniques: Shading adds depth and dimension to tattoos, transforming flat images into dynamic works of art. Different shading techniques include:

Hatching and Cross-Hatching: These techniques involve creating parallel or intersecting lines to build up shading. Hatching uses single-direction lines, while cross-hatching uses lines that cross over each other. These methods are effective for adding texture and gradient effects.

Stippling: Stippling involves creating shading with dots rather than lines. The density and size of the dots determine the shading intensity. This technique is ideal for achieving soft gradients and detailed textures.

Gradients: Smooth gradients transition from dark to light, creating a three-dimensional effect. Use a combination of needles, such as magnums and shaders, to blend ink

seamlessly. Gradual changes in pressure and machine speed help achieve smooth transitions.

Feathering: Feathering involves gently blending the edges of shaded areas into the skin. This technique softens the transitions between light and dark, enhancing the natural appearance of the tattoo. Feathering requires a light touch and careful control of the machine.

Black and Grey Shading: Black and grey shading uses different dilutions of black ink to create various shades of grey. This technique is essential for realism and portrait tattoos, where subtle tonal variations are crucial. Understanding how to mix and apply grey washes ensures a broad range of shading effects.

Blending and Smoothing: Effective shading often involves blending different areas smoothly. Use a circular motion or sweeping strokes to blend shades together. Proper blending eliminates harsh lines and creates a cohesive look.

Depth and Dimension: Consider the light source when shading to create realistic depth and dimension. Shading should mimic how light interacts with the subject, enhancing the three-dimensionality of the tattoo.

Practice and Precision: Mastery of line work and shading comes with consistent practice and attention to detail. Work on practice skins or sketch regularly to improve control and technique. Precision in both line work and shading ensures high-quality, professional tattoos.

Color Theory and Application: Understanding How Colors Work Together and How to Apply Them Effectively

Color theory and application are crucial aspects of tattoo artistry. Understanding how colors interact and how to apply them effectively can transform a tattoo from ordinary to extraordinary. Here's a comprehensive guide to mastering color in tattoos.

Color Theory Basics: Color theory is the study of how colors mix, match, and contrast with each other. The color wheel, a visual representation of colors arranged in a circle, is a fundamental tool for understanding color relationships.

Primary Colors: Red, blue, and yellow are the primary colors. They cannot be created by mixing other colors and serve as the foundation for all other colors.

Secondary Colors: Mixing two primary colors results in secondary colors: green (blue + yellow), orange (red + yellow), and purple (red + blue).

Tertiary Colors: These are created by mixing a primary color with a secondary color, resulting in hues like red-orange, yellow-green, and blue-purple.

Complementary Colors: Colors opposite each other on the color wheel, such as red and green or blue and orange, are complementary. When used together, they create high contrast and vibrant looks.

Analogous Colors: Colors next to each other on the color wheel, such as blue, blue-green, and green, are analogous. These combinations are harmonious and pleasing to the eye, often used for more subtle and cohesive designs.

Triadic Colors: A triadic color scheme uses three colors evenly spaced around the color wheel, such as red, yellow, and blue. This approach provides a balanced and dynamic palette.

Color Harmony: Achieving color harmony involves creating a pleasing balance in the design. This can be done through complementary, analogous, or triadic color schemes, ensuring that colors work together rather than clash.

Application Techniques: Applying color in tattoos requires skill and precision. Here are some techniques to consider:

Solid Fill: Solid fill involves applying a uniform color to an area. This technique requires even pressure and consistent movement to avoid patchiness and ensure full coverage.

Blending: Blending colors smoothly can create gradients and transitions. Use circular motions and overlapping strokes to blend one color into another seamlessly. Proper blending eliminates harsh lines and creates a more natural look.

Layering: Layering involves applying multiple colors in stages to build depth and richness. Start with lighter colors and gradually add darker tones. This technique is useful for creating complex textures and enhancing realism.

Highlighting: Adding highlights with lighter colors, such as white or light yellow, can enhance the tattoo's three-dimensional effect. Highlights should be applied sparingly and strategically to areas where light naturally hits.

Shadowing: Shadows are created with darker colors to add depth and dimension. Understanding the light source and applying shadows accordingly enhances the realism of the tattoo.

Color Saturation: Saturation refers to the intensity of a color. Highly saturated colors are vivid and bright, while desaturated colors are more muted. Adjusting saturation levels can create different moods and effects in the design.

Ink Quality: Using high-quality inks is essential for achieving vibrant and lasting colors. Poor-quality inks can fade quickly and result in uneven application. Always choose reputable

brands and ensure that the inks are safe and suitable for tattooing.

Client's Skin Tone: Consider the client's skin tone when selecting colors. Some colors may appear differently on various skin tones. Testing colors on a small area can help determine how they will look once healed.

Aftercare and Maintenance: Proper aftercare is crucial for preserving the vibrancy of colors. Advise clients on how to care for their tattoos, including avoiding sun exposure, keeping the area moisturized, and following healing instructions.

By mastering color theory and application techniques, tattoo artists can create vibrant, harmonious, and visually stunning tattoos. Understanding how colors interact and how to apply them effectively enhances the overall quality and impact of the artwork, ensuring that each tattoo is a masterpiece.

Chapter 6

Practicing on Synthetic Skin and Live Models

"Practice is the hardest part of learning, and training is the essence of transformation." - Ann Voskamp

The Importance of Practice in Tattooing

Tattooing is a skill that requires precision, control, and artistry. Like any other art form, practice is essential for mastering these skills. Practicing on synthetic skin and live models provides a safe and effective way to improve technique, build confidence, and prepare for real-world tattooing. This chapter explores the benefits and methods of practicing on both synthetic skin and live models.

Practicing on Synthetic Skin

Synthetic skin is an invaluable tool for aspiring tattoo artists. It offers a realistic surface for practice, allowing artists to hone their skills without the pressure and risk associated with tattooing on human skin. Here are the key aspects of practicing on synthetic skin:

Realistic Texture: High-quality synthetic skin mimics the texture and elasticity of human skin. This similarity provides a realistic practice surface, helping artists get accustomed to the feel of tattooing. Practicing on synthetic skin helps artists learn how to control needle depth, pressure, and machine speed effectively.

Safe Environment: Practicing on synthetic skin eliminates the risk of causing pain or injury. It allows artists to experiment with different techniques and styles without the consequences of a permanent tattoo. This environment is ideal for beginners who need to build confidence and refine their skills.

Repetition and Improvement: Synthetic skin can be used repeatedly, allowing artists to practice the same design multiple times. This repetition is crucial for improving muscle memory and consistency. Artists can focus on specific aspects of their technique, such as line work, shading, and color blending, until they achieve the desired proficiency.

Feedback and Analysis: Practicing on synthetic skin enables artists to analyze their work critically. They can examine the quality of their lines, the smoothness of their shading, and the vibrancy of their colors. Identifying areas for improvement helps artists develop a more refined and professional style.

Variety of Surfaces: Synthetic skin is available in various forms, including flat sheets, 3D shapes, and body part replicas. Practicing on different surfaces helps artists prepare for the

challenges of tattooing on different body parts. It provides an opportunity to practice on curved and uneven surfaces, simulating real-world tattooing scenarios.

Cost-Effective: Synthetic skin is a cost-effective practice tool. It is reusable and less expensive than the equipment needed for live models. Investing in high-quality synthetic skin provides a valuable resource for ongoing practice and skill development.

Transitioning to Live Models

While synthetic skin is an excellent practice tool, transitioning to live models is a critical step in becoming a proficient tattoo artist. Tattooing on live models introduces new challenges and considerations that are essential for real-world tattooing. Here are the key aspects of practicing on live models:

Understanding Skin Variability: Human skin varies greatly in thickness, texture, and elasticity. Practicing on live models helps artists learn how to adapt their techniques to different skin types. This adaptability is crucial for achieving consistent results and ensuring client satisfaction.

Real-Time Feedback: Tattooing on live models provides immediate feedback on technique and comfort. Models can communicate their pain levels, allowing artists to adjust their pressure and approach accordingly. This feedback is invaluable for learning how to provide a comfortable and positive experience for clients.

Managing Movement and Positioning: Tattooing on a live model requires managing their movement and positioning. Unlike synthetic skin, live models may move or shift during the tattooing process. Learning how to maintain control and precision in these situations is essential for delivering high-quality tattoos.

Hygiene and Safety Practices: Practicing on live models reinforces the importance of hygiene and safety. Artists must adhere to strict sterilization protocols to prevent infections and ensure the safety of their models. This practice helps artists develop habits that are essential for maintaining a professional and reputable tattooing practice.

Emotional and Psychological Factors: Tattooing is not just a physical process; it also involves emotional and psychological factors. Practicing on live models helps artists learn how to communicate effectively, manage client expectations, and provide a reassuring presence. Building strong client relationships is essential for long-term success in the tattoo industry.

Portfolio Development: Tattoos on live models contribute to an artist's portfolio, showcasing their skills and versatility. A diverse portfolio with high-quality work on various skin types and body parts is crucial for attracting clients and establishing a professional reputation.

Realistic Practice Scenarios: Practicing on live models simulates real-world tattooing scenarios, including dealing with different pain thresholds, skin reactions, and environmental factors. This experience prepares artists for the complexities and unpredictability of professional tattooing.

Ethical Considerations: When practicing on live models, it is essential to ensure that they are fully informed and consenting. Artists should provide detailed information about the risks, process, and aftercare involved in tattooing. Respecting the autonomy and well-being of models is a fundamental ethical responsibility.

Balancing Synthetic Skin and Live Model Practice

Both synthetic skin and live model practice have their unique benefits and challenges. Balancing practice on both surfaces is the most effective way to develop comprehensive tattooing skills. Here are some tips for integrating both practices:

Start with Synthetic Skin: Begin your practice on synthetic skin to build foundational skills. Focus on mastering line work, shading, and color application. Use synthetic skin to experiment with different styles and techniques without the pressure of tattooing on human skin.

Gradual Transition: Gradually transition to live models once you are confident in your basic skills. Start with small, simple designs and gradually progress to more complex pieces. This approach allows you to build confidence and experience in a controlled manner.

Seek Feedback: Whether practicing on synthetic skin or live models, seek feedback from experienced tattoo artists. Constructive criticism helps identify areas for improvement and provides guidance on refining your technique.

Document Progress: Keep a record of your practice sessions, including photos and notes. Documenting your progress allows you to track improvements, identify patterns, and set goals for future practice. It also provides a visual record of your development as an artist.

Stay Informed: Continuously educate yourself about new techniques, tools, and industry standards. Attend workshops, seminars, and conventions to learn from experienced artists and stay updated on the latest trends and practices.

Prioritize Hygiene: Always prioritize hygiene and safety, whether practicing on synthetic skin or live models. Follow sterilization protocols, use high-quality equipment, and ensure a clean and organized workspace. Maintaining high standards of hygiene is essential for your reputation and the well-being of your clients.

By incorporating both synthetic skin and live model practice into your training regimen, you can develop the skills, confidence, and experience needed to excel in the tattoo industry. Each practice method offers unique advantages that contribute to a well-rounded and professional approach to tattooing.

Using Synthetic Skin: Techniques for Practicing Without a Live Model

Practicing on synthetic skin is an essential step for aspiring tattoo artists. It offers a safe and effective way to refine techniques, build confidence, and develop a personal style without the risks associated with tattooing on human skin. Here are techniques and best practices for making the most of synthetic skin:

Choosing the Right Synthetic Skin: High-quality synthetic skin is designed to mimic the texture and elasticity of human skin. Look for products specifically made for tattoo practice, which are typically made from silicone or rubber. These materials provide a realistic surface that allows you to practice needle depth, pressure, and shading techniques accurately.

Setting Up Your Workspace: Create a clean and organized workspace for practicing on synthetic skin. Ensure that all your equipment, including tattoo machines, needles, inks, and cleaning supplies, is within easy reach. Maintain hygiene standards by using disposable barriers and regularly disinfecting surfaces. This setup not only simulates a

professional environment but also instills good habits for future tattooing on live models.

Basic Techniques: Start with basic techniques such as line work and simple shapes. Practice creating consistent lines by adjusting needle depth and pressure. Focus on smooth, continuous strokes to develop control and precision. As you become more comfortable, progress to more complex designs that incorporate shading and color blending.

Shading and Color Blending: Shading and color blending are crucial skills for creating depth and dimension in tattoos. Use different needle configurations, such as magnums and shaders, to practice various shading techniques. Experiment with hatching, cross-hatching, and stippling to achieve different textures and gradients. Practice color blending by layering different shades and using circular motions to create smooth transitions. Synthetic skin allows you to refine these techniques without the worry of causing pain or damage to a live model.

Realistic Practice Scenarios: To simulate real tattooing conditions, mount synthetic skin on a rounded object or a body part replica. This practice helps you adjust to the contours and movements of the human body. Working on curved surfaces enhances your ability to maintain consistent needle depth and pressure, which is essential for producing clean and accurate tattoos.

Feedback and Improvement: After each practice session, critically evaluate your work. Examine the quality of your lines, the smoothness of your shading, and the vibrancy of your colors. Identify areas where you can improve and set specific goals for your next practice session. Seeking feedback from experienced tattoo artists or mentors can also provide valuable insights and guidance.

Simulating Real Tattoos: Practice replicating real tattoos by using stencils and reference images. This exercise helps you develop the skills needed to transfer designs accurately from paper to skin. Pay attention to the details and strive for precision in every aspect of the tattoo.

Consistency and Patience: Building tattooing skills takes time and dedication. Practice regularly and be patient with your progress. Consistency is key to developing muscle memory and refining your technique. Celebrate small improvements and use each practice session as an opportunity to learn and grow.

Recording Progress: Keep a record of your practice sessions, including photos and notes. Documenting your progress allows you to track your development, identify patterns, and set goals for future practice. Reviewing your past work helps you see how far you've come and where you need to focus your efforts.

By using synthetic skin effectively, you can build a solid foundation of skills and confidence. This practice prepares you for the challenges of tattooing on live models and helps you

develop the precision and control needed for professional tattooing.

Transitioning to Live Models: Tips for Making the Switch

Transitioning from synthetic skin to live models is a significant step in a tattoo artist's journey. Tattooing on human skin introduces new challenges and variables that require adaptability and confidence. Here are tips for making a successful transition to live models:

Start with Simple Designs: Begin with small, simple designs that are less intimidating and easier to manage. This approach allows you to focus on technique and control without the added pressure of complex compositions. Gradually increase the complexity of your designs as you gain confidence and experience.

Understand Skin Variability: Human skin varies in thickness, texture, and elasticity across different body parts and individuals. Practice on friends or volunteers with different skin types to understand these variations. Learning to adapt your technique to different skin conditions is crucial for achieving consistent results.

Communication is Key: Establish clear communication with your live model before, during, and after the tattoo session. Explain the process, address any concerns, and ensure they are comfortable throughout the session. Encouraging feedback

from your model helps you adjust your technique and improve their experience.

Maintain Hygiene Standards: Adhering to strict hygiene protocols is essential when working with live models. Sterilize all equipment, use disposable needles and tubes, and wear gloves to prevent infection. Clean and prepare the skin thoroughly before starting the tattoo, and provide aftercare instructions to ensure proper healing.

Manage Movement and Positioning: Tattooing a live model requires managing their movement and positioning. Ensure your model is seated or lying comfortably and securely. Use adjustable chairs and armrests to position the body part you are working on at the optimal angle. Communicate with your model to minimize movement and maintain a steady working surface.

Work on Pain Management: Tattooing can be painful, and different individuals have varying pain thresholds. Monitor your model's comfort and adjust your technique accordingly. Taking short breaks and offering reassurance can help manage pain and keep your model relaxed.

Prepare for the Unexpected: Live models can present unexpected challenges, such as skin reactions, bleeding, or movement. Be prepared to adapt your technique and handle these situations calmly and professionally. Experience and practice will improve your ability to manage these variables effectively.

Build a Portfolio: Tattoos on live models contribute to your portfolio, showcasing your skills and versatility. Document your work with high-quality photos and notes. A diverse portfolio with various skin types and body parts demonstrates your competence and attracts potential clients.

Seek Constructive Feedback: After completing a tattoo, seek feedback from your model and other experienced tattoo artists. Constructive criticism helps identify areas for improvement and provides valuable insights into your technique. Use this feedback to refine your skills and enhance your future work.

Ethical Considerations: Ensure that your live models are fully informed and consenting. Discuss the risks, process, and aftercare involved in getting a tattoo. Respecting the autonomy and well-being of your models is a fundamental ethical responsibility that builds trust and credibility.

Continuous Learning: Transitioning to live models is an ongoing learning process. Stay informed about new techniques, tools, and industry standards. Attend workshops, seminars, and conventions to learn from experienced artists and stay updated on the latest trends and practices.

By following these tips, you can make a smooth and confident transition to tattooing live models. This experience is invaluable for developing the skills, adaptability, and professionalism needed for a successful career in tattoo artistry.

Conducting a Practice Session: How to Organize and Execute a Practice Tattoo Session

Conducting a practice tattoo session is essential for honing your skills and building confidence. Proper organization and execution ensure that the session is productive and beneficial. Here's a comprehensive guide to organizing and executing a practice tattoo session:

Set Clear Objectives: Before starting the practice session, set clear objectives. Determine what specific skills or techniques you want to focus on, such as line work, shading, or color blending. Having a clear goal helps you stay focused and measure your progress effectively.

Prepare Your Workspace: Ensure that your workspace is clean, organized, and well-equipped. Arrange your tattoo machine, needles, inks, and cleaning supplies within easy reach. Maintain hygiene standards by disinfecting surfaces and using disposable barriers. A well-prepared workspace simulates a professional environment and helps you develop good habits.

Select Your Practice Medium: Choose whether you will practice on synthetic skin or a live model. Each medium has its benefits, and your choice should align with your objectives. For beginners, starting on synthetic skin is advisable to build

foundational skills. As you progress, practicing on live models helps you adapt to real-world tattooing conditions.

Design Preparation: Prepare your design before the practice session. Create a stencil or sketch the design directly on the practice medium. Ensure that the design is clear, detailed, and appropriate for the skills you are focusing on. Proper preparation saves time and allows you to concentrate on the tattooing process.

Conducting the Session on Synthetic Skin:

- Mount the Synthetic Skin: Secure the synthetic skin on a flat or curved surface to mimic the body's contours. This setup helps you practice maintaining consistent needle depth and pressure on different surfaces.
- Begin with Basic Techniques: Start with basic techniques such as line work and simple shapes. Focus on creating clean, consistent lines and smooth shading. Gradually introduce more complex designs as you gain confidence.
- Evaluate and Adjust: Periodically stop to evaluate your work. Examine the quality of your lines, shading, and color application. Identify areas for improvement and adjust your technique accordingly. This practice helps you develop a critical eye and refine your skills.

Conducting the Session on Live Models:

- **Model Preparation:** Ensure that your model is fully informed and consenting. Discuss the design, process, and aftercare instructions. Prepare the skin by cleaning and shaving the area to be tattooed.
- **Positioning and Comfort:** Position your model comfortably and securely. Use adjustable chairs and armrests to ensure the area being tattooed is easily accessible. Communicate with your model to minimize movement and maintain a steady working surface.
- **Technique Application:** Apply the design using the appropriate needle configurations and techniques. Focus on maintaining consistent needle depth and pressure. Monitor your model's comfort and adjust your technique as needed.
- **Feedback and Improvement:** After completing the tattoo, seek feedback from your model and other experienced tattoo artists. Constructive criticism helps identify areas for improvement and provides valuable insights into your technique.

Document Your Work: Take high-quality photos of your practice tattoos. Documenting your work allows you to track your progress, identify patterns, and set goals for future practice. A visual record of your development is invaluable for building your portfolio and showcasing your skills.

Post-Session Review: After the practice session, review your work critically. Compare it to your objectives and identify areas where you succeeded and areas that need improvement.

Use this review to plan your next practice session and focus on specific skills that need refinement.

Continuous Practice: Conducting regular practice sessions is essential for continuous improvement. Set a consistent practice schedule and gradually increase the complexity of your designs. Consistency and dedication are key to developing muscle memory, precision, and control.

Seek Mentorship and Feedback: Engaging with experienced tattoo artists and seeking mentorship can accelerate your learning process. Attend workshops, seminars, and conventions to learn from industry professionals. Constructive feedback and guidance help refine your technique and enhance your overall skills.

By organizing and executing effective practice sessions, you can systematically improve your tattooing skills. Whether practicing on synthetic skin or live models, each session is an opportunity to learn, grow, and develop the expertise needed for a successful career in tattoo artistry.

Chapter 7

The Tattooing Process

"The body is a canvas, and tattoos are the brushstrokes that create a story."

The Art and Science of Tattooing

The tattooing process is a meticulous blend of art and science, requiring precision, skill, and a deep understanding of techniques and tools. Each step, from preparation to aftercare, is crucial for creating a high-quality tattoo and ensuring the client's safety and satisfaction. This chapter delves into the comprehensive process of tattooing, offering detailed insights into each stage.

Preparation: Setting the Stage

Preparation is the foundation of a successful tattoo session. It involves setting up a clean and organized workspace, ensuring the client is comfortable and informed, and preparing the necessary tools and materials.

Workspace Setup: A clean and organized workspace is essential for maintaining hygiene and efficiency. Disinfect all surfaces, including the tattoo station, chairs, and surrounding

areas. Arrange all necessary equipment, such as tattoo machines, needles, inks, and cleaning supplies, within easy reach. Use disposable barriers to cover surfaces and tools to prevent cross-contamination.

Sterilization: Sterilization is critical to prevent infections and ensure client safety. Autoclave all reusable equipment, such as grips and tubes, to kill any bacteria, viruses, and spores. Use single-use, pre-sterilized needles and cartridges. Wear disposable gloves throughout the tattooing process and change them if they become contaminated.

Client Consultation: A thorough client consultation ensures that you understand their vision and preferences. Discuss the design, placement, and any specific requests or concerns they may have. Review their medical history to identify any potential issues, such as allergies or skin conditions, that could affect the tattooing process.

Design Preparation: Create or finalize the tattoo design based on the client's input. Use a stencil or draw freehand on the client's skin to outline the design. Ensure the stencil is correctly placed and the client is satisfied with the positioning before proceeding. Double-check the design for accuracy and completeness.

The Tattooing Process: Step-by-Step

The actual tattooing process involves several stages, each requiring precision and attention to detail. Here's a step-by-step guide to executing a high-quality tattoo.

Skin Preparation: Clean the tattoo area with an antiseptic solution to remove any dirt, oil, or bacteria. Shave the area using a disposable razor to ensure a smooth surface. Apply a thin layer of stencil transfer solution and carefully position the stencil on the skin. Allow the stencil to dry completely before beginning the tattoo.

Outlining: The outline is the foundation of the tattoo, defining its structure and details. Use a liner needle to create clean, consistent lines. Start with the major outlines and then add finer details. Maintain a steady hand and consistent pressure to avoid uneven lines. Wipe away excess ink and blood with a disposable cloth as you work.

Shading: Shading adds depth and dimension to the tattoo. Use shader needles to create smooth gradients and transitions. Employ different shading techniques, such as hatching, cross-hatching, and stippling, to achieve the desired effect. Adjust the needle depth and machine speed based on the area being shaded and the desired intensity.

Coloring: Coloring involves filling in the tattoo with solid blocks of color or creating blended effects. Use magnum needles for large areas and round shaders for smaller sections. Apply the ink evenly to avoid patchiness. Blend colors smoothly to create gradients and transitions. Wipe the area regularly to maintain visibility and accuracy.

Highlighting: Highlighting adds contrast and emphasis to certain areas of the tattoo. Use white or light-colored ink to create highlights. Apply highlights sparingly and strategically to enhance the overall design. This step can make the tattoo pop and add a three-dimensional effect.

Final Touches: After completing the main components of the tattoo, inspect the design for any inconsistencies or areas that need touch-ups. Add any final details and ensure that the tattoo is clean and cohesive. This stage involves careful inspection and refinement to achieve the best possible result.

Post-Tattoo Care: Ensuring Proper Healing

Proper aftercare is essential for the tattoo to heal correctly and maintain its quality. Provide the client with detailed aftercare instructions to follow.

Immediate Care: After finishing the tattoo, clean the area with a mild, fragrance-free soap and water. Pat the area dry with a clean, disposable cloth. Apply a thin layer of a recommended aftercare ointment to keep the tattoo moisturized and protected.

Bandaging: Cover the tattoo with a sterile, non-stick bandage to protect it from dirt and bacteria. Some artists use plastic wrap, while others prefer breathable bandages. Instruct the client to keep the bandage on for a few hours to allow the initial healing process to begin.

Ongoing Care: Provide the client with a comprehensive aftercare guide. Advise them to wash the tattoo gently with mild soap and water twice a day, pat it dry, and apply a thin layer of aftercare ointment. Emphasize the importance of keeping the tattoo clean and moisturized without overdoing it.

Avoiding Complications: Instruct the client to avoid soaking the tattoo in water (e.g., swimming pools, hot tubs) and exposing it to direct sunlight until it is fully healed. Warn against picking or scratching the tattoo, as this can cause scarring and ink loss. Remind them to wear loose, breathable clothing to prevent irritation.

Signs of Infection: Educate the client about the signs of infection, such as excessive redness, swelling, pus, or a fever. Encourage them to contact you or seek medical attention if they notice any of these symptoms.

Client Follow-Up: Ensuring Satisfaction

1. Follow-up with clients after the tattoo session to ensure they are satisfied with the result and the healing process is progressing well.

2. Check-Ins: Schedule a follow-up appointment or check-in with the client after a few weeks. This allows you to assess the healing and address any concerns or touch-ups that may be needed.

3. Touch-Ups: Offer a complimentary touch-up session if the tattoo requires any adjustments after the initial healing period. This service ensures that the tattoo looks its best and maintains its quality.

4. Feedback and Reviews: Encourage clients to provide feedback and reviews of their experience. Positive feedback can help attract new clients, while constructive criticism can help you improve your techniques and services.

Continuous Improvement: Refining Your Craft

The tattooing process is a continuous journey of learning and improvement. Stay updated on new techniques, tools, and industry trends to refine your skills and offer the best possible service to your clients.

Education: Attend workshops, seminars, and conventions to learn from experienced artists and industry experts. Participate in online courses and forums to expand your knowledge and stay informed about the latest developments in tattooing.

Practice: Regular practice is essential for maintaining and improving your skills. Continue practicing on synthetic skin and live models to refine your techniques and experiment with new styles.

Networking: Build a network of fellow tattoo artists and industry professionals. Collaborate, share insights, and learn from each other. Networking can provide valuable opportunities for growth and development in your career.

By mastering the tattooing process and continually striving for improvement, you can ensure that each tattoo you create is a work of art that your clients will cherish for a lifetime. This commitment to excellence and professionalism sets the foundation for a successful and fulfilling career in tattoo artistry.

Preparing the Client and Work Area: Steps to Ensure a Smooth Tattooing Session

Preparing the client and the work area is crucial for a successful and smooth tattooing session. Proper preparation ensures hygiene, client comfort, and efficiency, setting the stage for high-quality work.

Client Consultation and Preparation:

1. Initial Consultation: Start with a thorough consultation to understand the client's vision, design preferences, and placement. Discuss any medical conditions, allergies, or skin sensitivities that could affect the tattooing process.

2. Skin Condition: Inspect the client's skin in the area to be tattooed. Ensure it is free of cuts, rashes, or sunburn. Healthy skin is essential for the best results and proper healing.

3. Informed Consent: Explain the process, potential risks, and aftercare procedures to the client. Ensure they sign a consent form acknowledging they understand and agree to the terms.

4. Comfort and Positioning: Make sure the client is comfortably positioned. Use adjustable chairs and armrests to provide support and access to the tattoo area. A comfortable client is less likely to move, leading to better results.

Work Area Setup:

1. Clean and Sterilize: Disinfect all surfaces, including the tattoo station, chairs, and surrounding areas. Use hospital-grade disinfectants to ensure a sterile environment.

2. Organize Tools and Supplies: Arrange all necessary equipment within easy reach. This includes tattoo machines, needles, inks, gloves, and cleaning supplies. Use trays or carts to keep tools organized and accessible.

3. Disposable Barriers: Cover all surfaces and equipment with disposable barriers. This includes armrests, work surfaces, and tattoo machines. Replace these barriers between clients to prevent cross-contamination.

4. Sterilized Equipment: Ensure all reusable equipment is properly sterilized using an autoclave. Use single-use, pre-sterilized needles and cartridges for each client.

5. Personal Protective Equipment (PPE): Wear disposable gloves, a mask, and an apron. Change gloves if they become contaminated and between different stages of the tattooing process.

Skin Preparation:

1. Clean the Area: Use an antiseptic solution to clean the client's skin, removing any dirt, oil, or bacteria. This step helps prevent infection.

2. Shave the Area: Shave the tattoo area using a disposable razor. This ensures a smooth surface and reduces the risk of infection. Clean the area again after shaving.

3. Apply Stencil: Apply a thin layer of stencil transfer solution to the skin. Place the stencil carefully, ensuring it is correctly positioned. Allow the stencil to dry completely before starting the tattoo.

Ensuring a Smooth Session:

1. Communication: Maintain open communication with the client throughout the session. Inform them about each step and check in on their comfort levels. Address any concerns promptly.

2. Hydration and Breaks: Encourage the client to stay hydrated and take short breaks if needed. This helps manage pain and reduces fatigue for both the client and the artist.

3. Monitor the Environment: Keep the workspace well-lit and maintain a comfortable temperature. Proper lighting ensures visibility, while a comfortable temperature helps the client relax.

By meticulously preparing the client and work area, tattoo artists can ensure a smooth and efficient tattooing session. This preparation is essential for creating high-quality tattoos and providing a positive experience for the client.

Outlining and Shading: Detailed Techniques for Both Outlining and Shading

Outlining and shading are fundamental techniques in tattooing that define the structure and depth of the design. Mastery of these techniques is crucial for creating detailed, high-quality tattoos.

Outlining Techniques:

1. Choosing the Right Needle: Use a liner needle for outlining. Liner needles come in various configurations, such as single needle (1RL) for fine lines and larger groupings (e.g., 5RL or 9RL) for bolder lines. Select the appropriate size based on the design requirements.

2. Consistent Pressure: Apply consistent pressure to achieve uniform lines. Too much pressure can cause blowouts, where the ink spreads under the skin, while too little pressure results in faint lines. Practice is essential to develop a steady hand and consistent pressure control.

3. Machine Speed and Voltage: Adjust the machine speed and voltage to suit the needle and skin type. Higher speeds are generally used for lining, but it's important to find the right balance to avoid damaging the skin.

4. Smooth, Continuous Strokes: Use smooth, continuous strokes to create clean lines. Avoid stopping and starting, as this can result in uneven lines. Plan the path of your lines to minimize interruptions.

5. Stretching the Skin: Use your non-tattooing hand to stretch the skin gently. This helps the needle penetrate the skin evenly and creates a smoother line. Proper skin tension is crucial for clean, precise outlines.

6. Wiping and Cleaning: Wipe away excess ink and blood regularly with a clean, disposable cloth. Keeping the area clean improves visibility and ensures accurate line work.

Shading Techniques:

1. Choosing the Right Needle: Use shader needles for shading. Common configurations include round shaders (RS) for smaller areas and magnum needles (M1 or M2) for larger areas. The choice of needle affects the texture and smoothness of the shading.

2. Layering: Build up shading gradually by layering ink. Start with lighter shades and gradually add darker tones. This technique creates depth and dimension without overworking the skin.

3. Directional Shading: Use directional shading techniques such as hatching and cross-hatching. Hatching involves parallel lines, while cross-hatching involves intersecting lines. These techniques create texture and gradient effects.

4. Feathering: Feathering involves blending the edges of shaded areas into the skin. Use a light touch and circular or sweeping motions to soften the transitions between light and dark areas. Feathering creates a smooth, natural look.

5. Smooth Gradients: Achieve smooth gradients by varying the pressure and speed of the needle. Start with light pressure and increase gradually to create a transition from light to dark. Consistent practice helps develop control over gradient shading.

6. Depth and Dimension: Consider the light source and shading to create realistic depth and dimension. Apply darker shades where shadows naturally fall and lighter shades where light hits. This approach enhances the three-dimensionality of the tattoo.

Blending Techniques:

1. Color Blending: For color tattoos, blending different hues creates smooth transitions. Apply the lighter color first, then blend the darker color into it using circular motions. Overlapping the colors slightly helps achieve a seamless blend.

2. Grey Wash: Grey wash shading involves diluting black ink with distilled water to create various shades of grey. Use different dilutions to build up gradients and achieve a range of tones. Grey wash is essential for realistic portraits and detailed designs.

Practice and Precision:

1. Practice on Synthetic Skin: Before working on live models, practice outlining and shading on synthetic skin. This helps develop muscle memory and precision.

2. Evaluate and Adjust: Continuously evaluate your work during the tattooing process. Make necessary adjustments to improve line quality and shading smoothness. Constructive self-critique and feedback from experienced artists are invaluable.

By mastering outlining and shading techniques, tattoo artists can create detailed and dynamic designs. These skills are the foundation of tattoo artistry, enabling artists to produce high-quality tattoos with depth, texture, and precision.

Coloring and Finishing Touches: How to Apply Color and Final Touches for a Professional Finish

Applying color and adding finishing touches are critical steps in the tattooing process. These techniques bring the design to life, adding vibrancy and depth. Mastering color application and finishing touches ensures a professional and polished final result.

Coloring Techniques:

1. Choosing the Right Needles: Use magnum needles for large areas of color and round shaders for smaller sections. Magnum needles allow for smooth, even coverage, while round shaders are ideal for detailed work.

2. Layering Colors: Build up color gradually by layering. Start with a light base and add darker shades on top. This technique prevents over-saturation and allows for better control of color intensity. Layering also helps in achieving rich, vibrant hues.

3. Blending Colors: To create smooth color transitions, blend colors seamlessly. Apply the lighter color first and then blend the darker color into it using circular or sweeping motions. Overlapping the colors slightly helps achieve a gradient effect. Practice blending on synthetic skin to develop consistency and precision.

4. Color Saturation: Ensure even color saturation by applying consistent pressure and needle depth. Uneven pressure can result in patchy or faded areas. Adjust your technique based on the skin type and location to achieve uniform color distribution.

5. Highlighting and Lowlighting: Use highlighting and lowlighting techniques to add dimension. Apply lighter colors, such as white or light yellow, to areas where light naturally hits. Use darker shades for shadows and recessed areas. This approach enhances the three-dimensionality and realism of the tattoo.

6. Color Palette: Select a cohesive color palette that complements the design and skin tone. Consider the interaction of colors and how they will age over time. High-quality inks ensure vibrant and long-lasting colors.

Finishing Touches:

1. Line Reinforcement: After applying color, reinforce the outlines to ensure they are sharp and clear. This step enhances the definition and contrast of the tattoo. Use a liner needle and consistent pressure for clean, precise lines.

2. Detail Work: Add intricate details and textures to enhance the overall design. Use fine needles for small elements, such as dots, lines, and textures. Detail work adds depth and complexity to the tattoo, making it more visually engaging.

3. White Highlights: Adding white highlights can make certain elements pop and add a polished finish. Use white ink sparingly to highlight specific areas, such as reflections or points of light. This technique enhances contrast and adds a professional touch.

4. Final Cleaning: Once the tattoo is complete, clean the area thoroughly with a mild, fragrance-free soap and water. Remove any excess ink, blood, and ointment. This step ensures the tattoo looks clean and allows for a clear view of the final result.

5. Assessment and Adjustment: Inspect the tattoo from different angles and under various lighting conditions. Make any necessary adjustments, such as adding more color or

reinforcing lines. Attention to detail during this final stage ensures the highest quality result.

Aftercare Instructions:

1. Immediate Aftercare: Apply a thin layer of a recommended aftercare ointment to the tattoo. Cover the area with a sterile, non-stick bandage or plastic wrap to protect it from dirt and bacteria.

2. Client Education: Provide the client with detailed aftercare instructions. Advise them to wash the tattoo gently with mild soap and water, pat it dry, and apply a thin layer of aftercare ointment. Emphasize the importance of keeping the tattoo clean and moisturized without overdoing it.

3. Avoiding Complications: Instruct the client to avoid soaking the tattoo in water (e.g., swimming pools, hot tubs) and exposing it to direct sunlight until it is fully healed. Warn against picking or scratching the tattoo, as this can cause scarring and ink loss. Remind them to wear loose, breathable clothing to prevent irritation.

4. Follow-Up: Schedule a follow-up appointment or check-in with the client after a few weeks to assess the healing process. Offer a complimentary touch-up session if needed to ensure the tattoo looks its best.

Continuous Improvement:

1. Practice and Feedback: Continuously practice color application and finishing techniques on synthetic skin and live models. Seek feedback from experienced artists and mentors to refine your skills.

2. Stay Informed: Stay updated on new techniques, tools, and industry trends. Attend workshops, seminars, and conventions to learn from experts and enhance your knowledge.

By mastering color application and finishing touches, tattoo artists can elevate their work to a professional level. These techniques ensure vibrant, detailed, and polished tattoos that stand the test of time, reflecting the artist's skill and dedication.

Chapter 8

Advanced Techniques and Specializations

"A work of art is a world in itself reflecting senses and emotions of the artist's world." - Hans Hofmann

The Evolution of Tattoo Artistry

As the art of tattooing continues to evolve, so do the techniques and specializations that artists employ. Mastering advanced techniques not only elevates the quality of work but also allows artists to explore new creative realms and offer clients unique, personalized experiences. This chapter delves into various advanced tattoo techniques and specializations, providing a comprehensive understanding of their application and benefits.

Advanced Techniques in Tattooing

Portrait Tattoos: Portrait tattoos require exceptional skill and attention to detail. These tattoos aim to replicate the likeness of a person, whether a loved one, celebrity, or historical figure.

1. Reference Images: High-quality reference images are crucial. Use multiple images to capture different angles and details. The more detailed the reference, the more accurate the tattoo will be.

2. Layering and Shading: Portraits rely heavily on layering and shading to create depth and realism. Use fine needles for detailed work and magnums for smooth shading. Gradually build up layers, starting with the lightest shades and moving to the darkest.

3. Understanding Anatomy: A deep understanding of human anatomy is essential. Knowing how light and shadow play on facial features helps create a lifelike representation.

Realism and Hyperrealism: Realism tattoos strive to create lifelike images, while hyperrealism takes it a step further, aiming to produce artwork that appears more real than reality itself.

1. Attention to Detail: Focus on minute details, such as skin texture, reflections, and subtle color variations. Every small element contributes to the overall realism.

2. Smooth Transitions: Achieving smooth transitions between colors and shades is crucial. Use a combination of stippling, soft shading, and blending techniques.

3. High-Quality Inks: Using high-quality inks ensures vibrant and long-lasting results. The right choice of colors can significantly impact the realism of the tattoo.

Black and Grey Tattoos: Black and grey tattoos, also known as monochromatic tattoos, use varying shades of black and grey to create depth and dimension.

1. Grey Wash Techniques: Mix different dilutions of black ink with distilled water to create various shades of grey. Practice grey wash techniques to achieve smooth gradients and realistic shadows.

2. Contrast and Depth: High contrast is key to creating depth. Use darker shades for shadows and lighter shades for highlights to make the design pop.

3. Texture and Detail: Focus on adding texture and fine details. Techniques like stippling and cross-hatching can enhance the realism and complexity of black and grey tattoos.

Geometric and Dotwork Tattoos: Geometric tattoos focus on shapes and patterns, while dotwork involves creating images using dots of varying sizes and densities.

1. Precision and Symmetry: Geometric tattoos require precise line work and symmetry. Use rulers and stencils to maintain accuracy.

2. Dot Density: For dotwork, control the density and size of dots to create shading and gradients. This technique requires patience and a steady hand.

3. Combining Techniques: Combine geometric patterns with dotwork to create intricate and visually striking designs. Experiment with different shapes and patterns to develop unique compositions.

Watercolor Tattoos: Watercolor tattoos mimic the appearance of watercolor paintings, using vibrant colors and abstract shapes.

1. Blending and Layering: Achieving the watercolor effect involves careful blending and layering of colors. Use a soft touch and circular motions to create smooth transitions.

2. Negative Space: Incorporate negative space to enhance the fluidity and transparency of the design. This technique helps mimic the lightness and flow of watercolor paints.

3. Color Palette: Choose a cohesive color palette that mimics the hues of watercolor paintings. High-quality inks ensure vibrant and long-lasting results.

Specializations in Tattooing

Cover-Up Tattoos: Cover-up tattoos involve designing tattoos to conceal existing ones. This requires creativity and strategic planning.

1. Assessment and Planning: Assess the existing tattoo and plan the cover-up design accordingly. Darker and more complex designs are usually easier to cover.

2. Layering and Shading: Use layering and shading techniques to blend the cover-up with the old tattoo. The goal is to obscure the old design while creating a new, cohesive artwork.

3. Client Consultation: Work closely with the client to understand their expectations and preferences. Clear communication is essential to ensure satisfaction with the final result.

Medical and Cosmetic Tattoos: These tattoos include procedures such as scar camouflage, areola reconstruction, and permanent makeup.

1. Understanding Skin Conditions: Knowledge of various skin conditions and how they affect tattooing is crucial. This ensures safe and effective results.

2. Specialized Equipment: Use specialized equipment and pigments designed for medical and cosmetic tattoos. These tools are often different from those used in traditional tattooing.

3. Precision and Subtlety: Medical and cosmetic tattoos require precision and subtlety. The goal is to create natural-looking results that enhance the client's appearance and confidence.

Biomechanical and Bio-Organic Tattoos: These styles combine elements of human anatomy with mechanical or organic forms, creating futuristic and otherworldly designs.

1. Creativity and Imagination: These styles offer a high degree of creative freedom. Experiment with combining mechanical elements, such as gears and circuits, with organic shapes like muscles and tendons.

2. Depth and Dimension: Use shading and perspective techniques to create depth and three-dimensionality. This enhances the realism and complexity of the design.

3. Integration with Body Contours: Design the tattoo to flow with the body's natural contours. This creates a cohesive and dynamic look that appears to move with the body.

Japanese Irezumi: Traditional Japanese tattoos, known as Irezumi, are rich in symbolism and history.

1. Cultural Knowledge: Understanding the cultural significance and symbolism of traditional Japanese motifs is essential. This knowledge ensures respect and authenticity in the designs.

2. Composition and Flow: Japanese tattoos are often large-scale and cover significant portions of the body. Pay attention to the composition and flow of the design to ensure it fits the body naturally.

3. Color and Detail: Use bold colors and intricate details to bring traditional Japanese designs to life. High-quality inks and precise line work are crucial for achieving the desired effect.

Continuous Learning and Innovation

Advanced techniques and specializations require continuous learning and innovation. Tattoo artists should stay updated on industry trends, attend workshops and conventions, and seek mentorship from experienced professionals. Experimentation and practice are key to mastering these advanced skills and expanding your artistic repertoire.

Workshops and Conventions: Attend industry events to learn from experts and network with other professionals. These events offer valuable opportunities to gain new insights and techniques.

Online Resources: Utilize online resources, such as tutorials, forums, and courses, to expand your knowledge and skills. The internet provides a wealth of information that can enhance your practice.

Mentorship: Seek mentorship from experienced tattoo artists. Mentors can provide guidance, feedback, and support, helping you navigate the complexities of advanced techniques and specializations.

Practice and Experimentation: Regular practice and experimentation are essential for mastering advanced techniques. Use synthetic skin and live models to refine your skills and explore new styles.

Portraits and Realism: Techniques for Creating Lifelike Tattoos

Portrait and realism tattoos are among the most challenging and rewarding styles in tattoo artistry. These tattoos aim to capture the likeness and essence of their subjects with incredible detail and accuracy. Here are essential techniques for creating lifelike tattoos:

High-Quality Reference Photos: The foundation of a successful portrait tattoo is a high-quality reference photo. Choose images with clear details, good lighting, and high resolution. Multiple reference angles can help in understanding the subject's features better.

Understanding Anatomy: A deep understanding of human anatomy is crucial. Knowing the structure of the face, muscle placements, and how light interacts with different surfaces helps in creating realistic tattoos. Study anatomical charts and practice sketching facial features to improve accuracy.

Outline with Precision: While realism tattoos often avoid harsh outlines, a light, precise outline can serve as a guide. Use fine liner needles to create subtle contours that help maintain the structure of the portrait without overwhelming it.

Layering and Shading: Layering and shading are critical for achieving depth and dimension. Start with the lightest shades and gradually build up to the darkest areas. Use various shading techniques, such as soft shading and stippling, to create smooth transitions and realistic textures.

Smooth Gradients: Achieving smooth gradients is essential for realism. Use magnum needles to blend shades seamlessly. Practice soft shading techniques to create gentle transitions between light and dark areas.

Texture and Detail: Adding texture enhances the realism of the tattoo. Pay attention to skin texture, hair strands, and other fine details. Use single needles or small configurations to add intricate details without overworking the skin.

Highlighting and Contrast: Proper use of highlights and contrast brings a portrait to life. Use white or lighter inks sparingly to add highlights where light naturally hits the face. Ensure strong contrast between light and dark areas to enhance depth and dimension.

Realistic Color Palette: For color realism, choose a palette that mimics natural skin tones and subtle variations. Use high-quality inks to ensure vibrant and long-lasting colors. Mix colors to achieve the perfect shades for different parts of the portrait.

Patience and Precision: Realism tattoos require patience and precision. Take your time to build up layers and details gradually. Working slowly and methodically ensures accuracy and reduces the risk of mistakes.

Feedback and Refinement: Seek feedback from experienced artists and mentors. Constructive criticism helps identify areas for improvement and refine techniques. Regular practice and continuous learning are essential for mastering realism.

By mastering these techniques, tattoo artists can create stunning, lifelike portraits that capture the essence and personality of their subjects, making each piece a unique work of art.

Cover-ups and Corrections: How to Handle and Fix Old or Unwanted Tattoos

Cover-up and correction tattoos involve transforming old, faded, or unwanted tattoos into new, appealing designs. This process requires creativity, strategic planning, and technical skill to achieve successful results.

Assessment and Planning: The first step in a cover-up or correction is a thorough assessment of the existing tattoo. Evaluate the size, color, and placement of the old tattoo. Discuss with the client their expectations and preferences for the new design.

Design Strategy: Choose a design that can effectively cover the old tattoo. Darker and more intricate designs are usually better for cover-ups. Consider elements like flowers, mandalas, or

abstract patterns that can mask the old tattoo's lines and colors.

Layering and Shading: Use layering and shading techniques to blend the old tattoo with the new design. Start by applying a solid base layer to obscure the old tattoo. Gradually build up layers with different shades and textures to create depth and complexity.

Color Choice: Dark colors like black, dark blue, and deep greens are effective for covering old tattoos. Bright colors can be used strategically to add highlights and details. Choose colors that complement the new design and effectively mask the old ink.

Incorporating the Old Design: Sometimes, elements of the old tattoo can be incorporated into the new design. This approach can add uniqueness to the cover-up and reduce the amount of ink required to conceal the old tattoo.

Precision and Detail: Pay close attention to details and edges to ensure the old tattoo is completely obscured. Use fine needles for detailed work and magnum needles for larger areas. Precision in application ensures a clean and cohesive final result.

Skin Condition: Consider the condition of the skin over the old tattoo. Scar tissue or uneven skin can affect the application of new ink. Adjust your technique accordingly, using lighter

pressure and careful shading to accommodate any irregularities.

Client Education: Educate the client about the cover-up process and realistic expectations. Inform them that multiple sessions may be required to achieve the desired result, especially for very dark or large old tattoos.

Aftercare Instructions: Provide detailed aftercare instructions to ensure proper healing. Advise the client to follow a strict aftercare regimen, including keeping the area clean, moisturized, and protected from the sun.

Continuous Learning: Stay updated on new techniques and advancements in cover-up tattooing. Attend workshops, seminars, and engage with other professionals to enhance your skills and knowledge.

By mastering the techniques of cover-ups and corrections, tattoo artists can transform unwanted tattoos into beautiful new designs, giving clients a renewed sense of confidence and satisfaction.

Special Effects and 3D Tattoos: Adding Depth and Dimension to Your Work

Special effects and 3D tattoos are at the forefront of modern tattoo artistry, pushing the boundaries of creativity and

technique. These tattoos create the illusion of depth and dimension, making the artwork appear to leap off the skin. Mastering these advanced techniques requires a deep understanding of shading, perspective, and color.

Understanding Depth and Perspective: The foundation of 3D tattoos lies in understanding how light, shadow, and perspective create the illusion of depth. Study the principles of perspective drawing, including vanishing points and foreshortening, to accurately depict three-dimensional objects on a two-dimensional surface.

Advanced Shading Techniques: Shading is crucial for creating depth. Use a combination of soft shading, stippling, and gradient techniques to achieve smooth transitions between light and dark areas. Gradual build-up of layers enhances the realism of the tattoo.

Highlights and Shadows: Proper placement of highlights and shadows is essential for the 3D effect. Highlights should mimic where light naturally hits the subject, while shadows should follow the contours and recesses. Use white or lighter inks sparingly to create realistic highlights and darker inks for deep shadows.

Color Theory and Application: Understanding color theory enhances the three-dimensional effect. Use contrasting colors to create visual separation between elements. Warm colors (reds, oranges) tend to advance, while cool colors (blues, greens) recede, creating a sense of depth.

Texture and Detail: Adding texture enhances the realism of 3D tattoos. Use fine needles to create detailed textures such as skin pores, fabric weaves, or surface irregularities. Attention to detail makes the tattoo more convincing and visually engaging.

Optical Illusions: 3D tattoos often incorporate optical illusions to enhance the effect. Techniques like trompe-l'oeil (trick the eye) can make elements of the tattoo appear as though they are physically protruding from or receding into the skin.

Layering and Depth: Use layering to create depth within the tattoo. Start with the background and gradually add foreground elements. This approach mimics the natural layering of objects in space and enhances the three-dimensional illusion.

Dynamic Compositions: Design dynamic compositions that interact with the body's contours. Placement on curved or prominent areas, such as shoulders, calves, or ribs, can enhance the 3D effect. Ensure the design flows naturally with the body's shape.

Client Collaboration: Work closely with clients to understand their vision and preferences. Discuss the feasibility of their ideas and provide guidance on achieving the best 3D effect. Clear communication ensures client satisfaction and realistic expectations.

Practice and Innovation: Regular practice is essential for mastering 3D techniques. Experiment with different styles, subjects, and approaches to refine your skills. Stay updated on

new trends and advancements in tattoo artistry to continuously push the boundaries of your work.

Aftercare for 3D Tattoos: Proper aftercare is crucial for maintaining the quality of 3D tattoos. Provide clients with detailed instructions, including how to care for their tattoo during the healing process and protect it from sun exposure and other damaging factors.

By mastering special effects and 3D tattoo techniques, artists can create visually stunning and innovative designs that captivate and impress. These advanced skills elevate tattoo artistry, offering clients unique and dynamic pieces that stand out as true works of art.

Chapter 9

Building Your Portfolio and Brand

"Your brand is what other people say about you when you're not in the room." - Jeff Bezos_

The Importance of a Strong Portfolio and Brand

In the competitive world of tattoo artistry, building a strong portfolio and personal brand is essential for standing out and attracting clients. A well-curated portfolio showcases your skills, versatility, and artistic style, while a cohesive brand communicates your professional identity and values. Together, they form the foundation of your reputation and success in the industry.

Creating a Compelling Portfolio

Diverse and High-Quality Work: Your portfolio should display a wide range of styles and techniques to demonstrate your versatility. Include examples of different types of tattoos, such as traditional, realism, black and grey, color, and abstract designs. Each piece should highlight your ability to execute various artistic elements, from fine line work to complex shading and color blending.

Professional Photography: High-quality images are crucial for showcasing your work effectively. Invest in a good camera or hire a professional photographer to capture your tattoos. Ensure that the photos are well-lit, clear, and taken from multiple angles to show the detail and craftsmanship of your work. Avoid using filters or heavy editing, as this can misrepresent the actual tattoo.

Before and After Shots: Including before and after shots of cover-up tattoos can demonstrate your skill in transforming old or unwanted tattoos into new, beautiful designs. This not only highlights your technical ability but also your creativity and problem-solving skills.

Client Testimonials: Incorporating testimonials from satisfied clients adds credibility to your portfolio. Positive feedback and personal stories about their tattoo experience can build trust with potential clients and highlight your professionalism and customer service.

Consistent Updates: Regularly update your portfolio with new work. This shows that you are active and continuously improving your craft. Remove older or less representative pieces to ensure that your portfolio always reflects your current skill level and artistic direction.

Digital and Physical Portfolios: Maintain both digital and physical versions of your portfolio. A digital portfolio can be shared easily on social media, websites, and online galleries. A

physical portfolio, often in the form of a high-quality photo book, is useful for in-person consultations and conventions.

Developing Your Personal Brand

Define Your Brand Identity: Your brand identity is the visual and emotional representation of your business. It includes your logo, color scheme, typography, and overall aesthetic. Choose elements that reflect your artistic style and personality. Consistency in these elements across all platforms helps create a recognizable and professional image.

Crafting a Mission Statement: A clear and concise mission statement communicates your values, goals, and what sets you apart from other artists. It should convey your commitment to quality, creativity, and client satisfaction. This statement can be featured on your website, social media profiles, and promotional materials.

Creating a Professional Website: A well-designed website is a central hub for your portfolio, contact information, and booking system. It should be easy to navigate, visually appealing, and mobile-friendly. Include an about page to share your story and philosophy, a gallery of your best work, client testimonials, and a blog to share insights and updates.

Leveraging Social Media: Social media platforms like Instagram, Facebook, and Pinterest are powerful tools for showcasing your work and engaging with potential clients. Post regularly, using high-quality images and engaging captions. Utilize hashtags to increase visibility and reach a broader audience. Interact with followers by responding to comments and messages promptly.

Networking and Collaboration: Building a strong network within the tattoo community and related industries can enhance your brand. Attend conventions, workshops, and industry events to connect with other artists, suppliers, and potential clients. Collaborate with other artists on projects to expand your reach and showcase your versatility.

Client Experience: Your brand is not just about your artwork but also the experience you provide to your clients. Ensure a welcoming, clean, and professional environment in your studio. Communicate clearly and professionally, from initial consultation to aftercare. Positive client experiences lead to word-of-mouth referrals and repeat business.

Marketing and Promotion: Utilize various marketing strategies to promote your brand. This can include online advertising, participation in local events, collaborations with influencers, and offering promotions or loyalty programs. Consistent and strategic marketing efforts help increase your visibility and attract new clients.

Brand Authenticity: Authenticity is key to building a loyal client base. Stay true to your artistic style and personal values. Clients are drawn to artists who are genuine and passionate about their work. Authenticity builds trust and long-term relationships with clients.

Continuous Learning and Adaptation: The tattoo industry is constantly evolving. Stay updated on new trends, techniques, and tools. Continuously improve your skills through workshops, courses, and practice. Adapt your brand and portfolio to reflect your growth and the changing landscape of the industry.

Tracking and Analyzing Performance: Regularly track and analyze the performance of your marketing efforts and portfolio engagement. Use analytics tools to understand what works and what doesn't. Adjust your strategies based on data to optimize your reach and effectiveness.

Building a Reputation

Consistency: Consistency in your work, communication, and branding efforts builds reliability and trust. Clients should feel confident that they will receive high-quality work and professional service every time.

Professionalism: Maintain professionalism in all interactions, whether online or in-person. This includes being punctual, respectful, and transparent with clients. Professionalism

enhances your reputation and encourages positive reviews and referrals.

Quality and Creativity: Focus on delivering exceptional quality and creativity in every tattoo. Your work is a reflection of your brand, and maintaining high standards will set you apart from competitors.

Client Relationships: Building strong relationships with clients is essential. Listen to their needs and provide personalized service. Follow up after appointments to ensure they are satisfied with their tattoos and address any concerns.

Community Engagement: Engage with your local community by participating in events, offering workshops, or supporting local causes. Community involvement enhances your brand's visibility and fosters a positive reputation.

By creating a compelling portfolio and developing a strong personal brand, tattoo artists can attract more clients, build a loyal following, and achieve long-term success in the industry. This combination of artistic excellence and strategic branding ensures that your work stands out and resonates with a broad audience.

Creating a Professional Portfolio: Showcasing Your Best Work

A professional portfolio is your most powerful tool for attracting clients and showcasing your skills as a tattoo artist. It serves as a visual resume, demonstrating your technical abilities, artistic range, and personal style. Here's how to create a portfolio that stands out:

Select Your Best Work: Choose only your highest-quality tattoos for your portfolio. Each piece should reflect your best effort and highlight your strengths. Avoid including incomplete or lower-quality work, as this can detract from your overall presentation. Aim for a diverse selection that shows your versatility across different styles, such as traditional, realism, black and grey, and color tattoos.

High-Quality Images: Invest in a good camera or hire a professional photographer to capture your work. High-quality images are crucial for showcasing the details and craftsmanship of your tattoos. Ensure that the photos are well-lit, in focus, and taken from multiple angles. Avoid using filters or heavy editing, as these can misrepresent the true appearance of the tattoo.

Before and After Shots: Including before and after photos of cover-up tattoos can demonstrate your skill in transforming old or unwanted tattoos. This not only highlights your

technical ability but also your creativity in overcoming design challenges.

Client Testimonials: Incorporate testimonials from satisfied clients to add credibility to your portfolio. Positive feedback and personal stories about their tattoo experience can build trust with potential clients and highlight your professionalism and customer service.

Consistent Updates: Regularly update your portfolio with new work. This shows that you are active and continuously improving your craft. Remove older or less representative pieces to ensure that your portfolio always reflects your current skill level and artistic direction.

Digital Portfolio: Create a digital portfolio that can be easily shared online. Use platforms like Instagram, Behance, or a personal website to showcase your work. Ensure that the digital portfolio is easy to navigate and visually appealing. Include contact information and links to your social media profiles.

Physical Portfolio: Maintain a physical portfolio for in-person consultations and conventions. A high-quality photo book or printed portfolio allows clients to see your work up close and appreciate the details. Ensure the physical portfolio is clean, well-organized, and professionally presented.

Organized Presentation: Organize your portfolio in a way that is easy to follow. Group similar styles together and arrange the pieces in a logical order. This helps potential clients quickly

find the type of work they are interested in and see the range of your abilities.

Detailed Descriptions: Provide brief descriptions for each piece in your portfolio. Include information about the design concept, techniques used, and any challenges you overcame. This gives potential clients insight into your creative process and technical expertise.

Special Projects and Collaborations: Highlight any special projects or collaborations you have worked on. This can include guest spots at other studios, participation in tattoo conventions, or collaborations with other artists. These experiences add depth to your portfolio and demonstrate your industry involvement.

By carefully curating and presenting your best work, you can create a professional portfolio that effectively showcases your talent and attracts potential clients.

Marketing Yourself as an Artist: Utilizing Social Media and Other Platforms

Marketing yourself as a tattoo artist is essential for building your brand, attracting clients, and growing your business. Utilizing social media and other platforms effectively can significantly enhance your visibility and reputation. Here's how to market yourself successfully:

Leverage Social Media: Social media platforms like Instagram, Facebook, and TikTok are powerful tools for showcasing your work and engaging with potential clients.

1. Instagram: Instagram is a visual platform that is ideal for tattoo artists. Post high-quality images of your tattoos, along with engaging captions that explain the design and process. Use relevant hashtags to increase visibility and reach a broader audience. Engage with your followers by responding to comments and messages promptly.

2. Facebook: Create a professional Facebook page to share your work, updates, and events. Use Facebook's advertising tools to target specific demographics and promote your services. Join tattoo-related groups to network with other artists and potential clients.

3. TikTok: TikTok is great for short, engaging videos. Share time-lapse videos of your tattooing process, client reactions, and behind-the-scenes content. This can help you reach a younger, tech-savvy audience.

Create a Professional Website: A well-designed website serves as a central hub for your portfolio, contact information, and booking system. Ensure that your website is easy to navigate, mobile-friendly, and visually appealing. Include an about page to share your story and philosophy, a gallery of

your best work, client testimonials, and a blog to share insights and updates.

Utilize Online Portfolios: Platforms like Behance and Dribbble allow you to create online portfolios that can be easily shared. These platforms are frequented by creative professionals and can help you reach a broader audience.

SEO Optimization: Optimize your website and online profiles for search engines. Use relevant keywords, such as "tattoo artist," "custom tattoos," and specific styles you specialize in. This helps potential clients find you more easily through online searches.

Email Marketing: Build an email list of clients and followers to keep them informed about your latest work, upcoming events, and special promotions. Regular newsletters can help maintain engagement and encourage repeat business.

Networking and Collaboration: Attend tattoo conventions, workshops, and industry events to network with other artists and potential clients. Collaborate with other artists on projects to expand your reach and showcase your versatility. Building a strong network within the tattoo community enhances your visibility and reputation.

Client Engagement: Provide exceptional customer service to build strong relationships with your clients. Encourage satisfied clients to leave positive reviews on your social media pages and other review platforms like Google My Business and Yelp. Word-of-mouth referrals are powerful marketing tools.

Content Creation: Regularly create and share content that showcases your expertise and personality. This can include blog posts, video tutorials, live Q&A sessions, and behind-the-scenes looks at your creative process. Engaging content helps establish you as an authority in the tattoo industry and keeps your audience interested.

Promotions and Giveaways: Run promotions and giveaways to attract new clients and engage your existing audience. Offer discounts, free consultations, or merchandise as prizes. These initiatives can increase your visibility and generate excitement around your brand.

By effectively utilizing social media and other platforms, you can market yourself as a skilled and professional tattoo artist. Consistent and strategic marketing efforts help build your brand, attract clients, and grow your business in the competitive tattoo industry.

Chapter 10

The Business of Tattooing

"Success in business requires training and discipline and hard work. But if you're not frightened by these things, the opportunities are just as great today as they ever were." - David Rockefeller

Understanding the Business Side of Tattooing

Tattooing is not just an art form; it's a business. To thrive as a professional tattoo artist, it's essential to master the business aspects of the industry. This chapter explores the critical elements of running a successful tattoo business, from financial management and marketing strategies to client relations and legal considerations.

Setting Up Your Business

Business Structure: The first step in establishing your tattoo business is choosing the right legal structure. Options include sole proprietorship, partnership, limited liability company (LLC), or corporation. Each structure has different implications for taxes, liability, and administrative requirements. Consult with a legal professional to determine the best fit for your situation.

Licensing and Regulations: Tattooing is a highly regulated industry. Obtain the necessary licenses and permits required by your local and state authorities. Compliance with health and safety regulations is crucial to operating legally and protecting your clients. Regular inspections and adherence to sterilization standards are mandatory.

Location and Studio Setup: Choosing the right location for your tattoo studio can significantly impact your business. Look for a space that is easily accessible, has good foot traffic, and offers a safe and welcoming environment. Design your studio to be clean, professional, and comfortable for clients. Invest in high-quality equipment and ensure that your workspace meets all health and safety standards.

Insurance: Protect your business with appropriate insurance coverage. General liability insurance covers accidents and injuries that may occur on your premises. Professional liability insurance, also known as malpractice insurance, protects against claims related to your services. Additionally, consider property insurance to cover your equipment and studio.

Financial Management

Budgeting and Forecasting: Develop a detailed budget that outlines your income and expenses. Track your earnings from tattoo sessions, merchandise sales, and other revenue streams. Monitor your expenses, including rent, supplies, utilities, and

marketing costs. Regularly update your budget and adjust your spending as needed to ensure financial stability.

Pricing Strategy: Setting the right pricing for your services is crucial. Consider factors such as your experience, the complexity of the design, and the market rates in your area. Charge enough to cover your costs and reflect the value of your work, but remain competitive. Transparent pricing helps build trust with clients and avoids misunderstandings.

Accounting and Bookkeeping: Maintain accurate financial records to track your income, expenses, and profits. Use accounting software to streamline the process and ensure accuracy. Keep receipts, invoices, and financial statements organized for tax purposes. Regularly review your financial reports to understand your business's financial health and make informed decisions.

Tax Obligations: Understand your tax obligations and comply with federal, state, and local tax requirements. This includes income tax, self-employment tax, sales tax (if applicable), and any other relevant taxes. Consider working with a tax professional to ensure compliance and maximize deductions.

Marketing and Promotion

Brand Identity: Develop a strong brand identity that reflects your artistic style and professional values. Your brand includes your logo, color scheme, typography, and overall aesthetic.

Consistency in branding across all platforms creates a cohesive and recognizable image.

Online Presence: Build a professional online presence through a well-designed website and active social media profiles. Your website should showcase your portfolio, provide information about your services, and offer an easy way for clients to contact you. Use social media platforms like Instagram, Facebook, and TikTok to share your work, engage with followers, and attract new clients.

SEO and Online Advertising: Optimize your website for search engines to increase visibility. Use relevant keywords, create high-quality content, and ensure your site is mobile-friendly. Consider investing in online advertising, such as Google Ads or social media ads, to reach a broader audience and drive traffic to your website.

Networking and Collaboration: Network with other tattoo artists and industry professionals to build relationships and gain referrals. Attend tattoo conventions, workshops, and industry events to connect with peers and showcase your work. Collaborate with other artists on projects to expand your reach and attract new clients.

Client Retention and Referrals: Focus on retaining existing clients by providing exceptional service and maintaining strong relationships. Encourage satisfied clients to refer friends and family by offering referral incentives or loyalty

programs. Positive word-of-mouth can significantly boost your business.

Client Relations

Consultations and Appointments: Conduct thorough consultations with clients to understand their vision and expectations. Use this time to discuss design ideas, placement, pricing, and aftercare. Clear communication ensures that both you and the client are on the same page, leading to a successful tattoo session.

Customer Service: Provide excellent customer service to create a positive experience for your clients. Be punctual, professional, and respectful. Listen to your clients' needs and concerns, and address any issues promptly. A positive client experience leads to repeat business and referrals.

Aftercare Support: Educate clients on proper aftercare to ensure their tattoo heals well and maintains its quality. Provide written aftercare instructions and be available to answer any questions they may have. Follow up with clients to check on their healing process and address any concerns.

Legal and Ethical Considerations

Contracts and Waivers: Use contracts and waivers to protect yourself and your clients. A contract outlines the terms of the service, including pricing, design approval, and aftercare responsibilities. A waiver releases you from liability in case of adverse reactions or complications. Ensure that these documents are clear, comprehensive, and legally binding.

Health and Safety Compliance: Adhere to all health and safety regulations to protect your clients and yourself. This includes proper sterilization of equipment, using disposable needles, maintaining a clean workspace, and following proper hygiene practices. Regularly review and update your safety protocols to stay compliant with industry standards.

Ethical Practices: Conduct your business with integrity and professionalism. Respect your clients' wishes and provide honest advice. Avoid copying other artists' work and always seek permission when using reference images. Uphold ethical standards in all aspects of your business to build a positive reputation.

Growth and Expansion

Setting Goals: Set short-term and long-term goals for your business. These could include increasing your client base, expanding your services, opening a new studio, or

participating in more conventions. Having clear goals helps you stay focused and motivated.

Continuous Learning: Stay updated with industry trends and continuously improve your skills. Attend workshops, take online courses, and seek mentorship from experienced artists. Continuous learning ensures that you remain competitive and can offer your clients the latest techniques and styles.

Diversifying Income Streams: Consider diversifying your income streams to enhance financial stability. This could include selling merchandise, offering online consultations or tutorials, or providing additional services like piercing or permanent makeup. Diversification can help mitigate risks and increase revenue.

Evaluating Performance: Regularly evaluate your business performance to identify areas for improvement. Use key performance indicators (KPIs) such as client retention rate, average revenue per client, and marketing ROI to measure your success. Make data-driven decisions to optimize your business operations.

Setting Up Your Tattoo Business: Legal Considerations, Licensing, and Business Models

Setting up a tattoo business involves more than just artistic skill; it requires thorough understanding and adherence to

legal considerations, proper licensing, and choosing the right business model. Here's a comprehensive guide to help you establish a successful and compliant tattoo business.

Legal Considerations

Business Structure: Choose the appropriate legal structure for your business. Options include sole proprietorship, partnership, limited liability company (LLC), or corporation. Each structure has different implications for liability, taxes, and administrative requirements. Consult with a legal professional to determine the best fit for your business needs.

Business Name and Registration: Select a unique and memorable name for your tattoo business. Ensure that the name is not already in use by another entity by checking with your local business registration office. Register your business name and obtain the necessary permits and licenses to operate legally.

Zoning and Location: Ensure that the location you choose for your studio complies with local zoning laws and regulations. Some areas have specific zones where tattoo businesses are allowed to operate. Verify with your local zoning department to avoid potential legal issues.

Contracts and Waivers: Use contracts and waivers to protect your business and your clients. A contract should outline the terms of service, including design approval, pricing, and

aftercare responsibilities. A waiver releases you from liability in case of adverse reactions or complications. Ensure these documents are clear, comprehensive, and legally binding.

Insurance: Obtain the necessary insurance to protect your business. General liability insurance covers accidents and injuries on your premises. Professional liability insurance protects against claims related to your services. Property insurance covers your equipment and studio. Consult with an insurance professional to ensure adequate coverage.

Health and Safety Compliance

Licensing and Permits: Tattoo artists and studios are subject to strict health and safety regulations. Obtain the necessary licenses and permits required by your local and state authorities. This typically includes a tattoo artist license, a studio license, and possibly a business license.

Sterilization and Hygiene: Adhere to stringent sterilization and hygiene practices to protect your clients and yourself. Use disposable needles and tubes, and sterilize reusable equipment with an autoclave. Maintain a clean and organized workspace, and follow proper hand hygiene practices. Regular inspections by health authorities ensure compliance with regulations.

Training and Certification: Complete any required training and certification programs. Some states require tattoo artists to undergo specific training in bloodborne pathogens, first aid,

and CPR. Staying current with certifications demonstrates your commitment to safety and professionalism.

Choosing a Business Model

Independent Studio: Operating an independent studio gives you full control over your business. You can design the space to reflect your style, set your own hours, and build a personal brand. However, it also requires significant investment in equipment, rent, and marketing.

Partnership: Forming a partnership with another artist or business can help share the costs and responsibilities. Ensure that you have a clear partnership agreement outlining each party's roles, responsibilities, and profit-sharing arrangements.

Booth Rental: Renting a booth in an established studio allows you to start with lower upfront costs. You benefit from the studio's existing clientele and reputation. However, you may have less control over the business environment and must adhere to the studio's policies.

Mobile Tattoo Business: Operating a mobile tattoo business involves traveling to clients' locations. This model offers flexibility and lower overhead costs. Ensure that you comply with local health and safety regulations, as mobile businesses may have specific requirements.

Franchise: Joining a tattoo franchise provides a proven business model, brand recognition, and support. Franchisees benefit from established systems, marketing, and training. However, this model requires adherence to franchise rules and often involves franchise fees and profit-sharing.

By thoroughly understanding legal considerations, obtaining the necessary licenses and permits, and choosing the right business model, you can establish a successful and compliant tattoo business. This foundation ensures that your business operates smoothly, attracts clients, and thrives in a competitive industry.

Pricing Your Work: How to Determine Fair Pricing for Your Tattoos

Determining fair pricing for your tattoos is crucial for the success and sustainability of your tattoo business. Proper pricing ensures that you cover your costs, reflect the value of your work, and remain competitive in the market. Here's a comprehensive guide to help you establish a fair and effective pricing strategy.

Factors Influencing Tattoo Pricing

Experience and Skill Level: Your experience and skill level significantly impact your pricing. More experienced artists with a proven track record and specialized skills can command higher prices. If you're starting out, you might price your work lower to attract clients and build your portfolio.

Design Complexity: The complexity of the tattoo design is a major factor in pricing. Intricate designs with detailed line work, shading, and color blending require more time and skill, thus justifying higher prices. Simpler designs or flash tattoos, which are pre-designed and often repeated, can be priced lower.

Size and Placement: The size and placement of the tattoo also affect pricing. Larger tattoos covering extensive areas of the body take more time and resources, leading to higher costs. Certain placements, like ribs or hands, can be more challenging and may require premium pricing.

Time and Effort: Consider the time and effort involved in creating the tattoo. This includes the time spent on consultation, design preparation, and the actual tattooing process. Some artists charge by the hour, which ensures that the price reflects the time invested in each piece.

Market Rates: Research the market rates in your area to ensure your pricing is competitive. Look at what other tattoo artists with similar experience and skills are charging. While it's important to remain competitive, avoid underpricing your work as it can undermine your perceived value and sustainability.

Materials and Overhead Costs: Account for the cost of materials, such as inks, needles, and sterilization supplies, as well as overhead costs like rent, utilities, and marketing

expenses. Ensuring that these costs are covered in your pricing is essential for maintaining profitability.

Establishing a Pricing Structure

Hourly Rate: Charging an hourly rate is a common practice in the tattoo industry. This method ensures that you are compensated for the time spent on each tattoo, regardless of its size or complexity. Determine an hourly rate based on your experience, skill level, and market rates. Be transparent with clients about your hourly rate and provide estimates based on the expected time required.

Flat Rate Pricing: For smaller or simpler tattoos, a flat rate pricing structure can be more straightforward. Determine a price based on the size and complexity of the design. This method can be appealing to clients who prefer to know the total cost upfront.

Minimum Charge: Establish a minimum charge to cover the basic costs associated with setting up and sterilizing equipment. This ensures that even small tattoos are profitable. The minimum charge should reflect the value of your time and resources.

Custom Quotes: For custom designs, provide personalized quotes based on the specific details of the tattoo. Consider factors such as design complexity, size, placement, and the time

required. Custom quotes allow for flexibility and ensure that each piece is priced appropriately.

Deposits: Require a deposit to secure an appointment. Deposits help reduce no-shows and ensure that clients are committed to their appointments. The deposit amount can be a flat fee or a percentage of the estimated total cost. Clearly communicate your deposit policy to clients.

Communicating Pricing to Clients

Transparency: Be transparent with clients about your pricing structure and any additional costs. Provide detailed estimates and explain the factors influencing the price. Transparency builds trust and helps clients understand the value of your work.

Consultations: Use consultations to discuss pricing with clients. This is an opportunity to understand their budget, explain your rates, and provide an accurate quote. Clear communication during consultations helps set expectations and avoid misunderstandings.

Payment Policies: Establish clear payment policies and communicate them to clients. Specify acceptable payment methods, deposit requirements, and the timing of payments. Ensure that clients are aware of any cancellation or rescheduling fees.

Value Proposition: Emphasize the value of your work to clients. Highlight your experience, skill level, and the quality of materials you use. Explain the time and effort involved in creating custom designs. Demonstrating the value of your work justifies your pricing and helps clients appreciate the investment they are making. Managing Finances and Inventory: Keeping Track of Expenses and Supplies Effective financial and inventory management is essential for the sustainability and growth of a tattoo business. Keeping meticulous records of expenses and supplies ensures that your business runs smoothly and profitably.

Financial Management

Budgeting: Establish a comprehensive budget that outlines your expected income and expenses. This includes fixed costs such as rent, utilities, and insurance, as well as variable costs like supplies and marketing. Regularly review and adjust your budget to reflect actual expenses and income, ensuring that your business stays financially healthy.

Tracking Income and Expenses: Use accounting software to track all financial transactions. Record every source of income, including tattoo sessions, merchandise sales, and tips. Similarly, document all expenses, from ink and needles to utility bills and marketing costs. Detailed records help you monitor cash flow and make informed financial decisions.

Tax Preparation: Set aside a portion of your income for taxes. Understand your tax obligations, including income tax, self-employment tax, and sales tax if applicable. Keep all receipts

and financial records organized for easy access during tax season. Consider hiring an accountant to ensure compliance and maximize deductions.

Inventory Management

Inventory Tracking: Maintain an inventory system to keep track of supplies. List all items, including inks, needles, gloves, and cleaning products. Use inventory management software or spreadsheets to monitor stock levels and track usage rates. Regularly update your inventory to avoid shortages and overstocking.

Ordering Supplies: Establish relationships with reliable suppliers to ensure a steady supply of high-quality materials. Order in bulk when possible to benefit from discounts, but be mindful of expiration dates and storage limitations. Schedule regular inventory checks and place orders proactively to maintain adequate stock levels.

Cost Control: Monitor the cost of supplies and seek cost-effective alternatives without compromising quality. Compare prices from different suppliers and negotiate discounts for bulk purchases. Efficient inventory management helps control costs and improve profitability.

Waste Reduction: Implement practices to reduce waste and maximize the use of supplies. Proper storage and handling of materials can extend their shelf life and minimize losses. Train staff on efficient use of supplies to prevent unnecessary waste.

By managing finances and inventory effectively, tattoo artists can ensure their business operates efficiently and profitably. Accurate financial tracking and efficient inventory management are foundational practices that support the long-term success and sustainability of a tattoo business.

Ethics and Professionalism: Maintaining High Standards in Your Practice

Maintaining high standards of ethics and professionalism is crucial for building a reputable and successful tattoo practice. Ethical behavior and professional conduct not only enhance client trust but also contribute to the overall integrity of the tattoo industry.

Ethical Practices

Client Consent: Always obtain informed consent from clients before starting a tattoo. Clearly explain the process, potential risks, and aftercare instructions. Ensure clients understand and agree to the terms by having them sign a consent form. Respect their decisions and boundaries throughout the tattooing process.

Confidentiality: Protect the privacy of your clients. Do not disclose personal information or details about their tattoos without explicit permission. Maintaining confidentiality fosters trust and demonstrates respect for your clients' privacy.

Honesty and Transparency: Be honest and transparent with clients about your abilities, pricing, and the tattoo process. Do not make false promises or misrepresent your skills. If a design

is beyond your expertise, refer the client to a more suitable artist. Transparency builds trust and credibility.

Originality and Respect for Art: Respect the intellectual property of other artists. Avoid copying or reproducing designs without permission. Encourage clients to seek unique, custom designs rather than replicating existing tattoos. Promoting originality and creativity maintains the integrity of the art form.

Professional Conduct

Hygiene and Safety: Adhere to strict hygiene and safety protocols to protect clients and yourself. Use sterilized equipment, disposable needles, and gloves. Maintain a clean and organized workspace. Regularly update your knowledge of health and safety standards and comply with local regulations.

Punctuality and Reliability: Be punctual and reliable in all client interactions. Honor appointment times and communicate promptly if changes are necessary. Consistent reliability fosters a positive reputation and client loyalty.

Professional Appearance: Maintain a professional appearance and demeanor. Dress appropriately and ensure that your studio reflects a professional and welcoming environment. First impressions are important and contribute to clients' overall experience.

Continuous Improvement: Commit to continuous learning and improvement. Stay updated with industry trends, new

techniques, and best practices. Attend workshops, conventions, and training programs to enhance your skills and knowledge. Demonstrating a commitment to professional growth underscores your dedication to excellence.

Client Relations: Build strong relationships with clients through respectful and attentive communication. Listen to their needs and provide personalized service. Follow up after tattoo sessions to ensure satisfaction and address any concerns. Positive client relationships lead to repeat business and referrals.

Conclusion

"A tattoo is not just a piece of art, but a lifetime memory."
- Damien Blood

As we reach the conclusion of this comprehensive guide, "Tattoo for Beginners to Intermediate: A 30-Day Journey to Tattoo Mastery," it is essential to reflect on the journey we have undertaken together. This book has aimed to equip you with the knowledge, skills, and confidence needed to excel in the art and business of tattooing.

Embracing the Art of Tattooing

Tattooing is an ancient art form that has evolved dramatically over the centuries. From the rich cultural significance of traditional tattoos to the cutting-edge techniques of modern styles, tattooing is a dynamic and ever-changing field. As a tattoo artist, you are not only creating visual art but also becoming a part of your clients' personal stories and memories.

The chapters in this book have covered a wide range of topics, including the history and cultural significance of tattoos, the technical aspects of tattooing, and the business side of running a successful tattoo practice. Each section has been designed to

provide you with detailed, practical information that you can apply directly to your work.

Mastering Techniques and Building Skills

We've journey into essential techniques such as line work, shading, and color application, emphasizing the importance of practice and continuous learning. Advanced techniques and specializations, such as realism, cover-ups, and 3D tattoos, were also explored to help you expand your artistic repertoire and offer more to your clients.

Practicing on synthetic skin and live models has been highlighted as crucial for skill development. These practices allow you to refine your techniques, gain confidence, and transition smoothly to working on real clients. Understanding the healing process, skin anatomy, and aftercare is vital to ensure the longevity and quality of your tattoos.

The Business of Tattooing

Running a successful tattoo business requires more than just artistic talent. We've provided insights into setting up your business, managing finances and inventory, and establishing fair pricing for your work. Ethical practices, professionalism, and client relations are foundational to building a reputable and thriving practice.

Marketing yourself as an artist involves creating a compelling portfolio, utilizing social media, and networking within the industry. Continuous learning and staying updated with new trends and techniques ensure that you remain competitive and relevant in this dynamic field.

Looking Ahead

Your journey as a tattoo artist is an ongoing process of growth and discovery. The skills and knowledge you've gained from this book are just the beginning. As you continue to hone your craft, remember that each tattoo you create is a unique expression of art and a lasting impact on your clients' lives.

Stay passionate, keep learning, and embrace the creative challenges that come your way. The world of tattooing is vast and full of opportunities for those who are dedicated and driven by a love for the art.

Thank you for embarking on this journey with us. We hope this book has inspired you, enriched your understanding, and equipped you with the tools needed to succeed in the art and business of tattooing. Here's to your continued growth and success in creating beautiful, meaningful tattoos.

www.ingramcontent.com/pod-product-compliance
Lightning Source LLC
Chambersburg PA
CBHW052316220526
45472CB00001B/149